PRINT'S BEST LOGOS & SYMBOLS 6

PRINT's Best Logos & Symbols 6
Library of Congress Catalog
Card Number
89-091068
ISBN 1-883915-09-0

RC Publications
President and Publisher:
Howard Cadel
Vice President and Editor:
Martin Fox
Creative Director:
Andrew P. Kner
Associate Art Director:
Michele L. Trombley
Associate Editor:
Katherine Nelson
Assistant Editor:
Robert H. Treadway III

Writer/Editor
Caitlin Dover
Art Director
Andrew P. Kner
Project Supervisor
Katherine Nelson
Assistant Editor
Robert H. Treadway III
Art Assistant
Charisse Gibilisco

Winning Designs from **Print** *Magazine's* *National Design Competition*

PRINT'S BEST LOGOS & SYMBOLS 6

Introduction

"I work like a dog," declares designer Betsy Wernert in her self-promotional logo. It looks like she's not the only one who can make that claim. This edition's designers have obviously labored hard to produce such innovative pieces. Some did so under chaotic conditions: According to Robert Pizzo, who produced the logo for *The Wall Street Journal*'s Night Shift column, "Sometimes there are small children running through the house while I work." Many designers, working alone, were responsible for all aspects of the symbols they produced, from lettering to illustration. One can imagine an oft-uttered phrase at presentations this past year: "Thanks, I did it myself." Those who worked in creative teams were no less diligent, pooling their talents to produce designs that raised money, raised arm-hair, and invariably raised clients' profiles with their customers.

The surest sign that this book's designers—whose logos and symbols all appeared in recent editions of PRINT magazine's Regional Design Annual—do indeed work hard is that they were eager to share their stories about those occasions when a design came to them easily and fully formed. Says Andrea Thomas of her soccer-ball symbol for non-profit organization Play On!: "It was the kind of thing where I saw it and said 'That's it!' without any hair-pulling. I wish every project was like that!"

What else smooths the way to a good logo besides the sudden cooperation of the muse? Well, an amiable client certainly helps. Speaking of the logo he designed for the Crazy Horse Saloon, Doug Malott of Communications Arts Associates says, "The client was very agreeable, and when that happens, a good logo emerges." On the other hand, though an unyielding client is usually the last thing a designer wants, some designers here benefited from their clients' well-defined requirements. Pizzo, for instance, received a three-sentence fax from his client—"Idea: office tower with two lights on. Crescent moon out. Space for, or incorporate the words, 'Night Shift.'" On the phone with his art director, Pizzo found that they were both already on the same page concept-wise, and by the end of the conversation he had doodled a draft of the final logo. Blake Tannery of The Buntin Group described the firm's client, the owner of Cat's Paw Clothing, as "a cat freak— she wanted evidence of cat in the symbol. I had no choice but to combine cat and clothing." Not too thrilled with these restrictions, Tannery nevertheless ended up using them to his advantage, creating a logo that interprets "evidence of cat" literally—and wittily—via a "woven" pattern of scratch marks.

The most desirable client-designer relationship, and possibly the one most conducive to a quick design process, is where client and designer understand each other from the start. Beth Singer, who produced the symbol for Hillel: The Foundation

for Jewish Campus Life, says: "This was a three-day project that went smoothly because of our thorough knowledge of the client's business and our Jewish background."

Of course, creativity has obviously been well-nurtured by these designers irrespective of client support. The diversity and originality of the logos in these pages makes that clear. There is no wholesale reliance on "retro" imagery, or on the creative abilities of the computer. Rather, we see designers using past forms as a springboard for new ideas, and often using the computer in its best capacity, as a tool to refine and streamline. The logos that actually owe their look to the computer do so in a well-conceived way. One glance at the self-promotional marks for designer David Hoffman and Hothouse Design + Advertising, for example, and you know two things: 1) the design was computer-generated and 2) no other method would have produced the desired effect. These designers have deliberately chosen the computer as their medium, and brought to that choice the same careful judgment that would apply to any other aspect of the design process.

That said, it does seem as if hand techniques are making a significant comeback. A fair number of these designers have (gasp!) actually put pen to paper at some stage of logo development. In some cases, we even have the thumbnail sketches to prove it. At least one designer not only drew his own design by hand, but took care of the printing end of things as well: Cliff Jew turned his thought-provoking self-promotional symbol into a rubber stamp, simultaneously giving his work just the right appearance and, one imagines, drastically reducing his printing costs.

Cliff Jew's art was inspired by chopstick packaging. Others derived their imagery, and even their type, from equally out-of-the-way sources. Rory Myers bought alphabet blocks for his kids' clothing logo; Scott Severson's symbol for production company Picture Factory was born out of an antique photography catalog. The undeniable winner of the award for strangest source of imagery is TKO Advertising, who designed the logo for "Bike Month" in Austin, Texas. Their designer, Josh Finto, "turned a nasty bike accident into the visual foundation of a great logo." TKO enclosed a photograph of Finto's bruised ankle, bearing the uncomfortable-looking marks of a bicycle chain, which apparently inspired Finto to design his bike-chain star. As TKO says, "Design can be a painful process."

While most designers will concur with that piece of wisdom, they will no doubt also agree that what is painful to produce better be painless to behold. A good logo, like good dance or music, should appear effortless. Hard work produced the designs in these pages, but if the designers didn't tell about it, who would know? They make it look so easy.—*Caitlin Dover*

CONTENTS

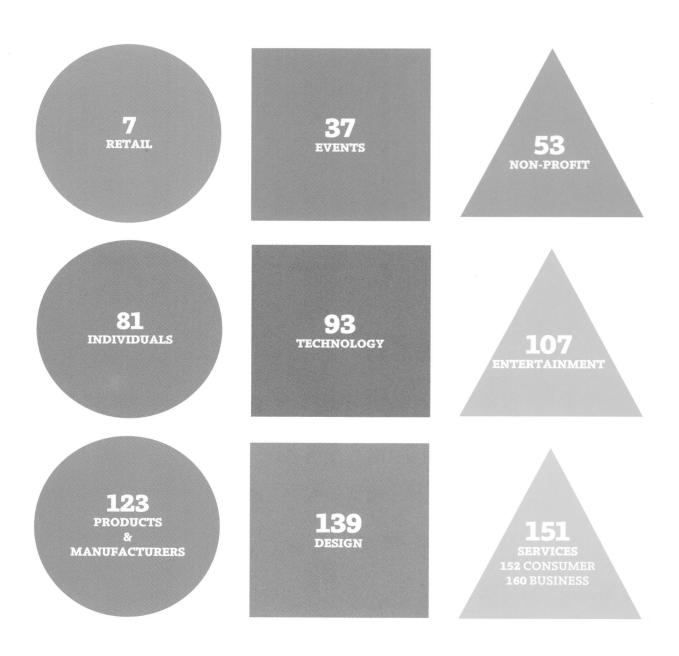

*R*etail

It is generally the case that, when designing for a client, you're also designing for the client's customers. Never is that more true than in retail, where the logo often becomes closely identified with the merchandise via the ever-present shopping bag. The shopper gets home, and before wearing his new shoes or trying on her new hat, these items must be extracted from a bag that bears a carefully conceived store logo. Sherrie and Tracy Holdeman at Insight Design Communications understood this fully. Their logo for Richard Lynn's Shoe Market—a stylized bag full of shoes—not surprisingly made a smooth transition from business cards and signage to paper sacks. The decorative bags were so popular that at Christmas the store was inundated with requests from customers who wanted them to wrap presents. The moral seems to be that when it comes to retail, the best designs don't just look good on the tags or over the door—they also travel well.

That dictum can also easily apply to restaurants and hotels. Restaurants routinely send their patrons home with a pocketful of identity—that is, matchboxes—and hotels find multitudes of ways to ensure that their visitors keep mementos of their stay lingering around the house, in the form of shampoo bottles and cakes of soap. Designing the identity for The Time Hotel in New York, Mirko Ilić came up with a fresher approach that also proved to be cost-effective. He applied the logo for the new, hip hotel to perfume samples, vacuum-sealed in a clear plastic square. The packaging combines the logo, printed on the front, with five die-cut postcards printed on one side with a photo of Times Square and on the other with an analysis of one of the primary colors used in each of the hotel's rooms. These ingenious freebies were produced for $1.10 a unit, despite the difficulties of incorporating plastic and metal into the final design.

Aside from adhering well to promotional materials, the logo itself needs to evoke the atmosphere of the place it promotes. Creative lettering is one way to do it. According to Ilić, the rooms at The Time are "very cozy and precise, thus the square fitting snugly into the *H* is appropriate." Annette Berry, when redesigning the logo for a dance club called Swing 46, sought out "type that that looks modern with a nod to the era of swing dancing." Others in this section relied on illustration, often hand-drawn, to give people a feeling for a place before they even walk in the door. For the restaurant Backstage at Bravo, Carmichael Lynch chose to project the theater eatery's ambience with a variety of little stylized ink sketches, each describing a scene from backstage life. These illustrations can be used all together or separately, depending on the application.

Whimsical renditions of real scenarios work well for a post-theater audience, but when you've got tough customers, it pays to range freely into the wilderness of pure fantasy. To appeal to the adventurous outdoorsmen attending a lodge that offers horseback riding and fishing, the Reimler Agency went with the image of a cowboy riding a fish, rodeo-style. The logo, illustrated by Roger Xavier, apparently has "captured the daredevil spirit people want to be associated with when choosing this kind of vacation." A fish (albeit a dead one) also figures in Toolbox's logo for a skate park called The Tank. Todd Coats, who art-directed the piece, needed something that would look good on a T-shirt and give off an aura of skate-punk cool. The hand-drawn fish skeleton, with the letters of "tank" as ribs, fulfilled these requirements, and Toolbox received the ultimate accolade: The skaters have proclaimed the logo "rad."

Of course, sometimes the client really just wants to communicate exactly what's on offer, be it food, music or beer. That was the case with Cheerleaders Sports Bar and Grill. They asked for one image that would combine their three main attractions: spirits, darts and billiards. Ryan Kaneshiro's solution? Take one martini, transform the swizzle stick into a dart and turn the olive into an eightball. Cheers!

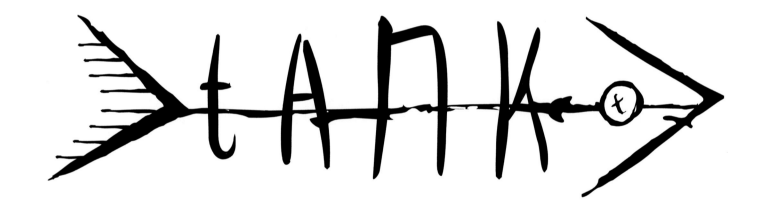

Logo for a skate park.

Design Firm:
Toolbox
Cary, NC
Art Director:
Todd Coats
Designers:
Todd Coats, Casey Foster
Illustrator:
Todd Coats

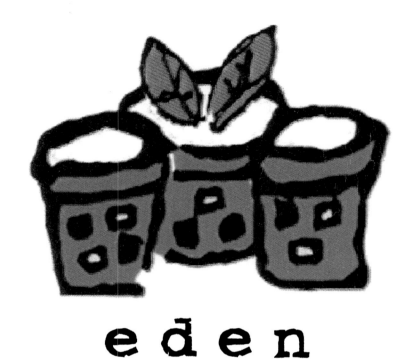

eden

Logo for an as yet nonexistent garden store being developed by the designer and her sister.

Design Firm:
Seran Design
Dunn Loring, VA
Art Director:
Sang Yoon
Designer:
Hillary Breen
Illustrator:
Hillary Breen

"an urban gardener's paradise"

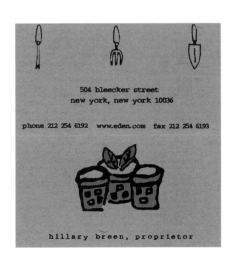

504 bleecker street
new york, new york 10036

phone 212 254 6192 www.eden.com fax 212 254 6193

hillary breen, proprietor

Rangoon News Bureau

Logo for a newsstand at the Mandalay Bay Resort & Casino in Las Vegas.

Design Firm:
LoBue Creative
Dallas, TX
Art Director:
Gary LoBue, Jr.
Designer:
Gary LoBue, Jr.
Illustrator:
Gary LoBue, Jr.
Client:
David Carter
Design/Mandalay Bay Resort
& Casino
**Project coordinator for
David Carter Design:**
Lori B. Wilson

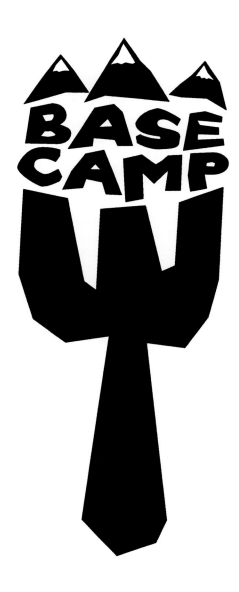

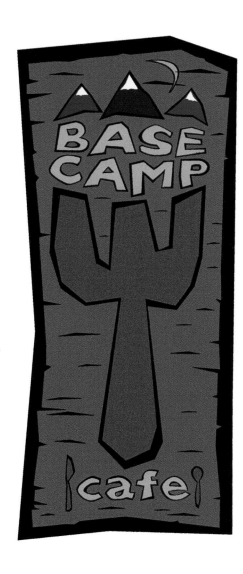

Logo for a café located inside a sporting goods store.

Design Firm:
Sheba Concept & Design
Minneapolis, MN
Art Director:
Cathy Fideler
Designer:
Cathy Fideler
Illustrator:
Cathy Fideler

HARD PRECIPITATION MILD PRECIPITATION LIGHT PRECIPITATION

WIND FACTOR FINE DAY

Weather icons for a mail-order athletic clothing company.

Design Firm:
Laura Coe Design Associates
San Diego, CA
Principal:
Laura Coe Wright
Illustrator:
Ryoichi Yotsumoto

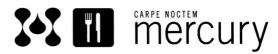

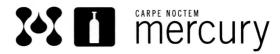

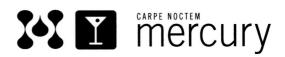

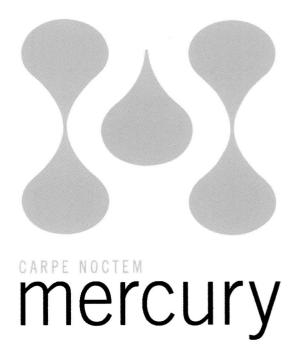

CARPE NOCTEM

mercury

Logos for an upscale restaurant and nightclub.

Design Firm:
Brand A Studio
San Francisco, CA
Art Director:
Guthrie Dolin
Designers:
Guthrie Dolin, Julie Cristello

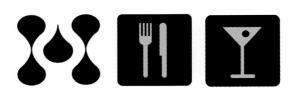

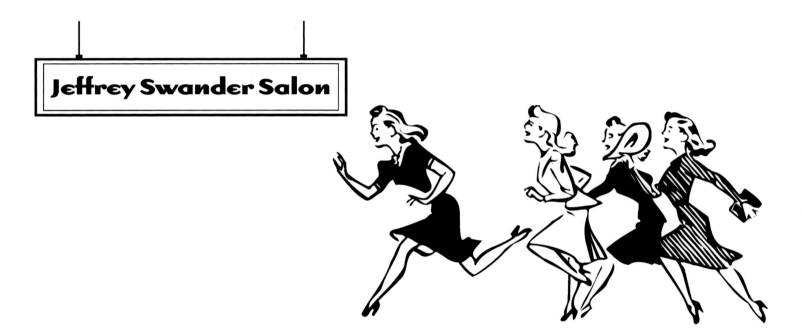

Jeffrey Swander Salon

Logo for a beauty salon.

Design Firm:
B Design
New York, NY
Art Director:
Brian Wong
Designer:
Brian Wong

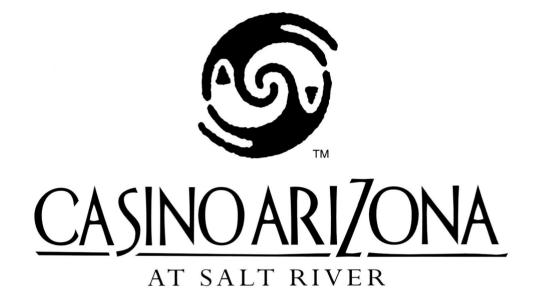

Identity for a casino run by the Pima-Maricopa Indian Community.

Design Firm:
Harris & Love Advertising
Salt Lake City, UT
Senior Art Director:
Preston Wood
Designer:
Haven Simmons

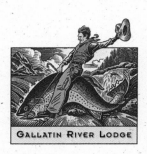

Logo for a riding and fishing lodge.

Design Firm:
The Reimler Agency
Charlotte, NC
Art Directors:
Bill Owens, Lynda Folz
Designer:
Bill Owens
Illustrator:
Roger Xavier

9105 Thorpe Rd Bozeman MT 59718 Tel 888.387.0148 406.388.0148 Fax 406.388.6766 sgamble@grlodge.com www.grlodge.com

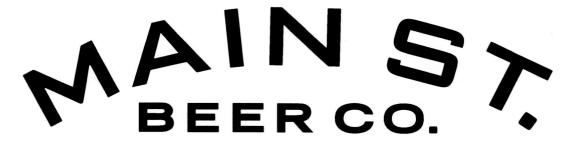

*Logo for a restaurant
and brewery.*

Design Firm:
Haley Johnson Design Co.
Minneapolis, MN
Art Director:
Cabell Harris
Designer:
Haley Johnson
Illustrator:
Haley Johnson

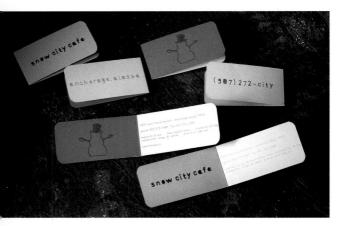

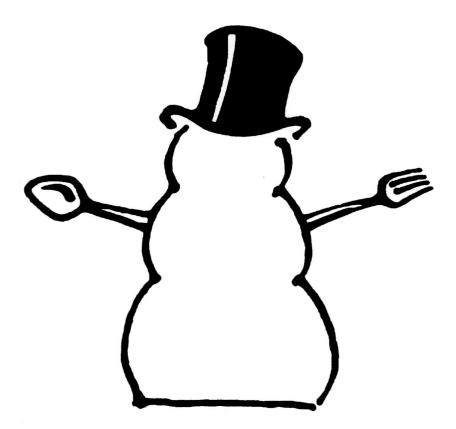

Symbol for a diner in Anchorage, Alaska.

Design Firm/Agency:
Weis Design
Seattle, WA
Art Director:
Lonnie Weis
Designer:
Lonnie Weis
Illustrator:
Lonnie Weis

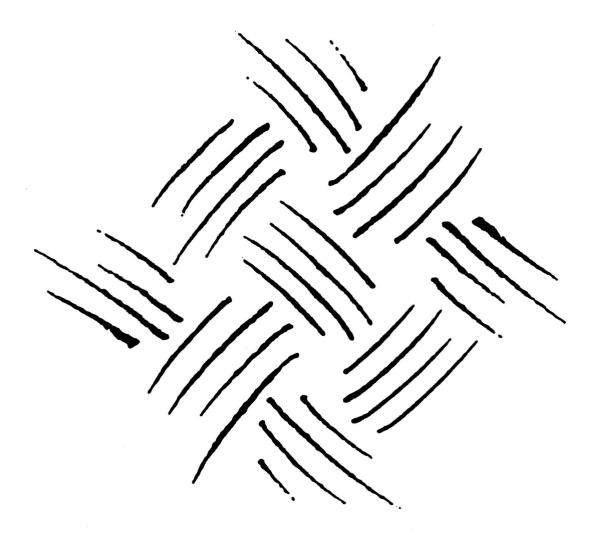

cat'spaw
clothing

Logo for a clothing store.

Design Firm/Agency:
The Buntin Group
Nashville, TN
Art Director:
Blake Tannery
Designer:
Matt Staab
Illustrator:
Matt Staab

BACKSTAGE
AT BRAVO

BACKSTAGE
AT BRAVO

BACKSTAGE
AT BRAVO

Logos for an upscale restaurant at Bravo Entertainment Center in Minneapolis, Minnesota.

Agency:
Carmichael Lynch Thorburn
Minneapolis, MN
Art Director:
David Schrimpf
Creative Director:
Bill Thorburn
Designer:
David Schrimpf
Illustrator:
Ed Fotheringham

BACKSTAGE
AT BRAVO

BACKSTAGE
AT BRAVO

Symbols for a basket company.

Design Firm:
SGL Design
Phoenix, AZ
Art Director:
Art Lofgreen
Illustrator:
Randy Heil

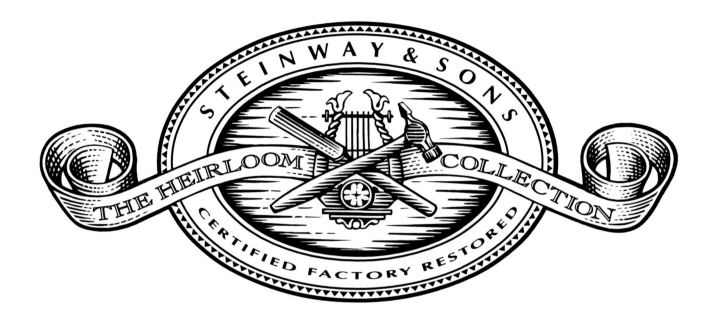

*Logo for a collection of
vintage pianos.*

Design Firm:
Wallwork Curry Sandler
Boston, MA
Art Director:
Mark Bappe
Illustrator:
Kent Barton
Client:
Steinway & Sons

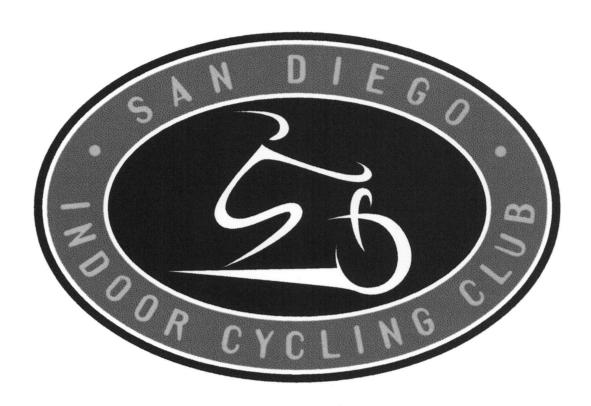

*Logo for a
fitness/spinning center.*

Design Firm:
Mires Design
San Diego, CA
Art Director:
Jose Serrano
Designers:
Jose Serrano,
Fumiko Tamura
Illustrator:
Fumiko Tamura

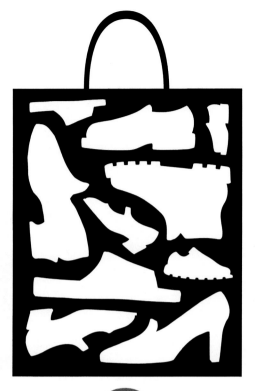

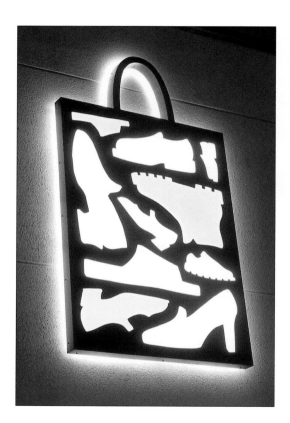

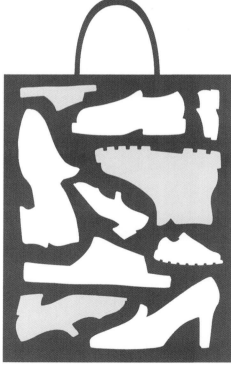

Symbol for a shoe store.

Design Firm:
Insight Design
Communications
Wichita, KS
Art Directors:
Sherrie Holdeman,
Tracy Holdeman
Designers:
Sherrie Holdeman,
Tracy Holdeman
Photographer:
Gavin Peters

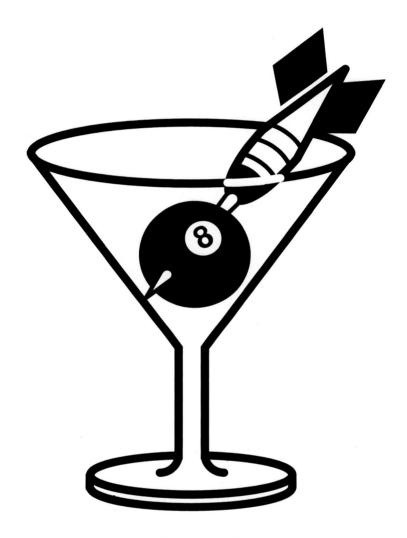

Logo for a sports bar and grill.

Design Firm:
Ryan Kaneshiro
Graphic Design
Honolulu, HI
Art Director:
Ryan Kaneshiro
Designer:
Ryan Kaneshiro

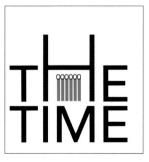

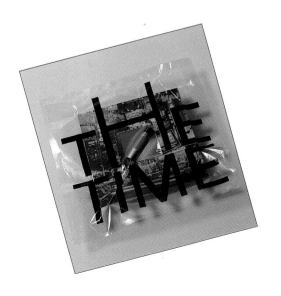

Logo for a Manhattan hotel.

Design Firm:
Mirko Ilić Corp.
New York, NY
Art Director:
Mirko Ilić
Designer:
Mirko Ilić
Client:
Adam D. Tihany
International Ltd.

Symbol for a diving equipment shop.

Design Firm:
Tom Fowler Inc.
Stamford, CT
Art Director:
Thomas G. Fowler
Designer:
Thomas G. Fowler

the whole body nurtured

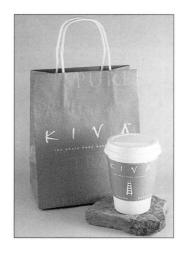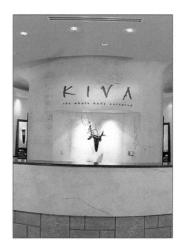

Identity for a Chicago spa.

Design Firm:
Chute Gerdeman, Inc.
Columbus, OH
Art Director:
Susan Hessler
Designer:
Adam Limbach
Client:
Kiva Corporation

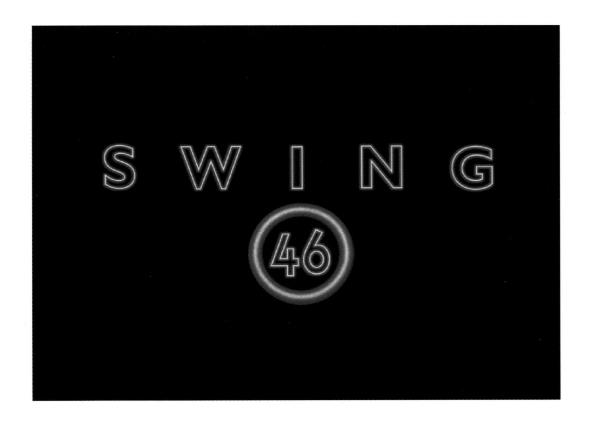

Logo for a dance club offering dinner and live music.

Design Firm:
Annette Berry Design for
The Chameleon Group
New York, NY
Designer:
Annette Berry

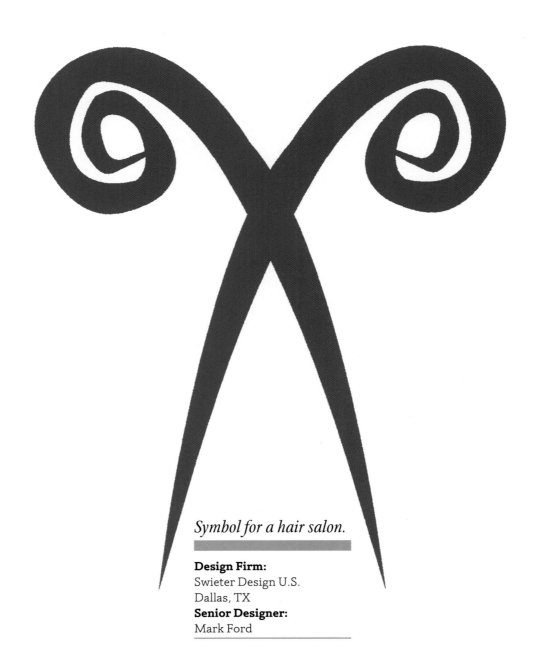

Symbol for a hair salon.

Design Firm:
Swieter Design U.S.
Dallas, TX
Senior Designer:
Mark Ford

Logo for a furniture studio.

Design Firm:
Swieter Design U.S.
Dallas, TX
Senior Designer:
Mark Ford

Logo for a company that sells plants that only need watering twice a year.

Design Firm:
Fervor Creative
Scottsdale, AZ
Art Directors:
Don Newlen,
Jami Pomponi Alire
Designers:
Don Newlen,
Jami Pomponi Alire
Illustrator:
Don Newlen

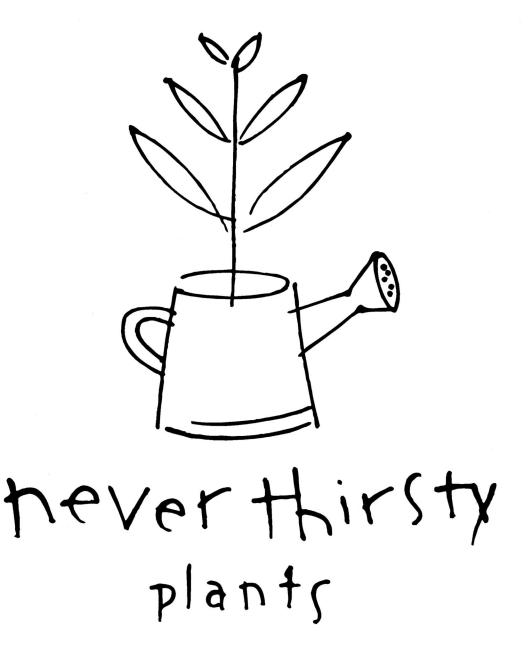

Symbol for a restaurant and bar offering live music.

Design Firm:
Communication Arts
Associates
Richmond, VA
Art Director:
Doug Malott
Designer:
Doug Malott
Illustrator:
Doug Malott

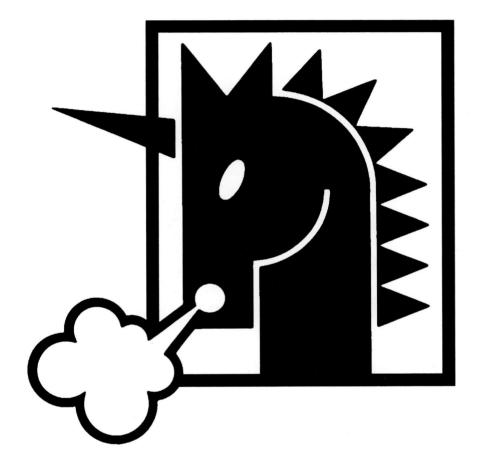

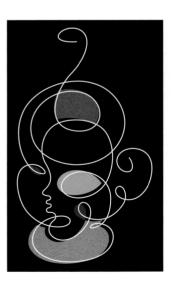

Symbol for a café in San Francisco.

Design Firm:
Felix Sockwell Creative
Brooklyn, NY
Designer:
Felix Sockwell
Illustrator:
Felix Sockwell

**Benbrook Lighted Par-3
Golf Course**
1590 Beach Road
Benbrook, Texas 76126
817.249.0770
www.benbrook3par.com

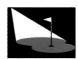

*Symbol for a golf course
that's open evenings.*

Agency:
Witherspoon Advertising
Fort Worth, TX
Creative Director:
Debra Morrow
Art Director:
Randy Padorr-Black
Designer:
Randy Padorr-Black
Illustrator:
Randy Padorr-Black
Digital Artist:
Robert Bulger
Account Executive/ACD:
Carol Glover

**Benbrook Lighted Par-3
Golf Course**
1590 Beach Road
Benbrook, Texas 76126

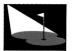

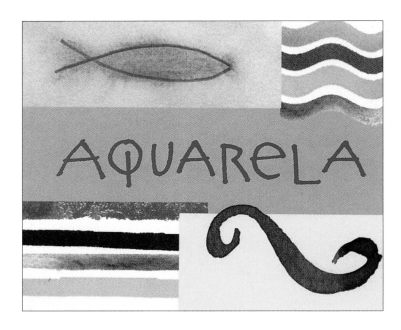

Logo for a restaurant in San Juan, Puerto Rico.

Design Firm:
Jak Design
New York, NY
Art Director:
Jill Korostoff
Designers:
Jill Groeber, Jan Baker

*E*vents

Robynne Ray at Modern Dog describes the conference for which Vittorio Costarella designed a logo: "This was the first annual user conference for Tidemark Computer Systems, a permit plan software developer for government agencies. The client wanted to make sure attendees had fun at the June event. The idea was that it should be nothing tech-y—just a chance for government employees to let their hair down."

Event logos often present an opportunity for designers to let their hair down, too. Many of the events represented in these pages—ranging, rather widely, from Israel's 50th birthday to a tenth anniversary pig roast—were celebratory occasions, and that spirit of celebration was obviously catching in the design studios responsible for their symbols. Quite a few of these studios shunned the aid of the computer, rendering the predominately playful imagery by hand. Case in point: Costarella announced the Tidemark festivities via that symbol of all things summer and fun, an orange popsicle. The hand-drawn image ended up enhancing the conference in more ways than one: Tidemark was inspired by the logo to actually hand out popsicles to its clients after the conference.

Whimsy also presided during the creation of a logo for Denbury Resources' '98 company picnic. After discarding concepts that were based on more run-of-the-mill picnic imagery, Eisenberg And Associates settled on an anthropomorphic oil-rig, holding knife and fork in readiness for the meal.

This character had the added benefit of looking spiffy on T-shirts, one of the standard accessories of any event worth its salt. Lanny Sommese learned the necessity of the event-logo-to-T-transfer the hard way. His symbol for the One-Eyed Open, a golf tournament raising money for an eye bank, had plenty of humor and personality (due, no doubt, to the fact that, as he says, "Eye drew it myself"). But it ended up being too loud on the shirt, and the final result looked, as Sommese puts it, "too much like a T-shirt, as opposed to a golf shirt."

Kevin Akers' symbols for the San Francisco Symphony's Black & White Ball made the leap onto T-shirts without a hitch. But the delightful spinning shoes (hand-drawn, yet again) were not his first idea. The Ball's committee wanted to replace their initial logo, a dancing couple, with something that would appeal to singles and couples alike. Akers' first concept consisted of spinning tops, but he switched to shoes in order to show the diversity of the audience. This final concept also shares the cartoonish charm of Eisenberg's "Rig Man"; while the tops conveyed little more than a sense of motion, the shoes really say, "you should be dancing."

Charm is only occasionally admitted to be an attribute of pigs, as memorably discussed in the film *Pulp Fiction*. And, appropriately enough, considering the purpose of this particular event, the pig in Phil Evans' logo for Wilcox Farm's 10th Anniversary pig roast is more stylized than personable. Evans had originally tried out a more realistic pig, or even 10 pigs forming a *W*. In the end, he refined his design down to the roman numeral, the porcine snout and four sharp pink trotters—perhaps the only lighthearted logo here that didn't mean good times for all comers.

Logo for an all-day polo event benefiting The Alabama Symphony.

Design Firm:
Lewis Communications
Birmingham, AL
Art Directors:
Robert Froedge,
Rich Albright
Creative Director:
Spencer Till

POLO FOR THE CLASSICS
A Benefit For The Alabama Symphony

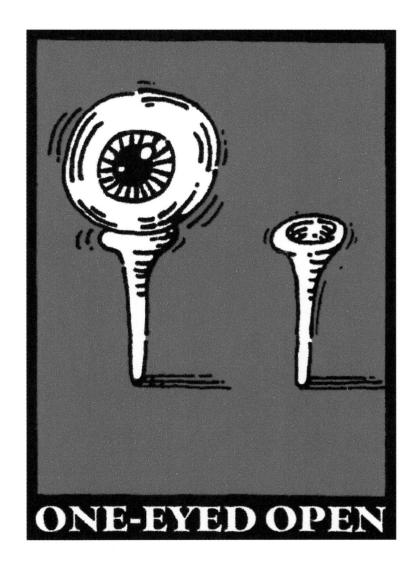

ONE-EYED OPEN

Logo for an annual charity golf event established by a group of golfers with only one good eye. All fully-sighted participants play wearing an eye patch.

Design Firm:
Sommese Design
State College, PA
Designer:
Lanny Sommese

CH. Luge

CH. Curling

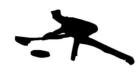

CH. Snowboard

CH. Bobsleigh

CH. Short Track

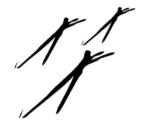

CH. Cross Country

CH. Ski Jumping

CH. Ice Hockey

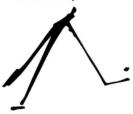

CH. Nordic Combined

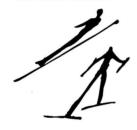

CH. Speed Skating

CH. Biathlon

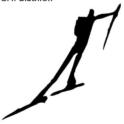

CH. Figure Skating

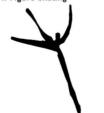

CH. Downhill

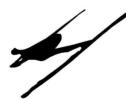

Event symbols for the 2006 Olympic bid of Klagenfurt, Austria.

Design Firm:
Copeland Hirthler Design &
Communications
Atlanta, GA
Art Directors:
Brad Copeland,
George Hirthler
Designers:
Mike Weikert, Todd Brooks,
David Woodward
Illustrator:
Todd Brooks
Client:
Klagenfurt 2006
Organizations GMBH

CH. Freestyle

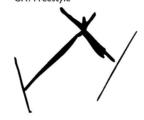

CH. Slalom

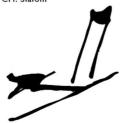

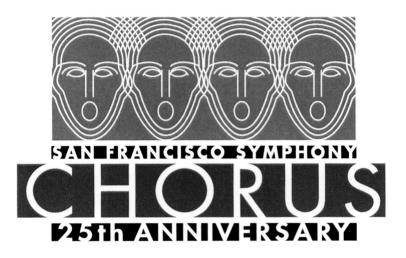

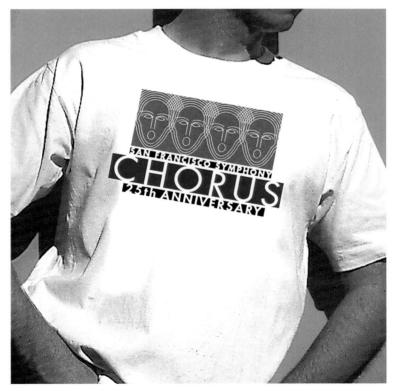

Logo commemorating the 25th Anniversary of the San Francisco Symphony Chorus.

Design Firm:
Kevin Akers-Designer
San Rafael, CA
Art Director:
Kevin Akers
Designer:
Kevin Akers
Illustrator:
Kevin Akers
Chorus Director:
Vance George

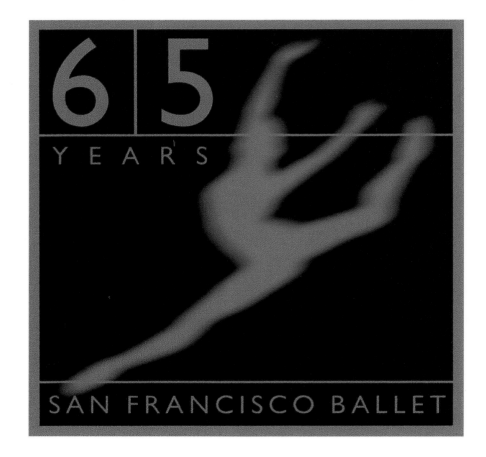

Logo for the San Francisco Ballet's 65th anniversary.

Design Firm:
Schulte Design
San Francisco, CA
Principal:
Paul Schulte
Photographer:
R.J. Muna

Logo for annual Bach Festival sponsored and hosted by the Camerata Singers of Long Beach, California.

Design Firm:
Simon Design
Newport Beach, CA
Art Directors:
Melanie Crandell,
Jason Simon, Tom Hall
Designer:
Jason Simon

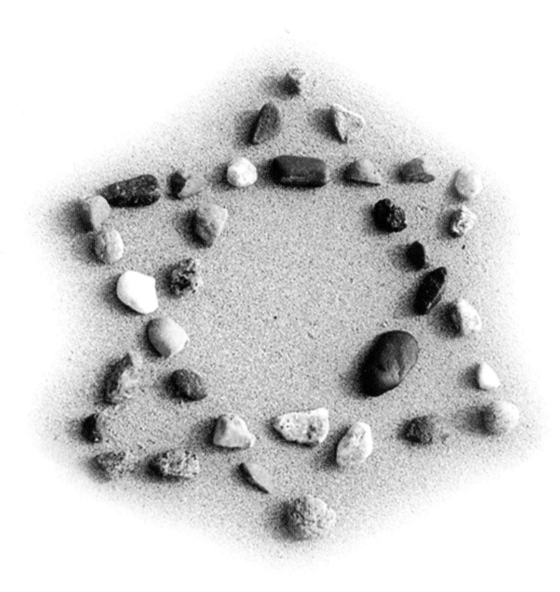

Logo for Israel's 50th birthday celebration.

Design Firm:
Gill Fishman Associates
Cambridge, MA
Art Director/Creative Director:
Gill Fishman
Designer:
Tammy Torrey
Photographer:
Thomas Torrey

Symbol for long-term corporate charitable events benefiting the people of China.

Design Firm:
Y&P Design International
Calabasas, CA
Creative Director:
Wenping Hsiao
Designer:
Wenping Hsiao
Illustrator:
Wenping Hsiao
Client:
Ting Yi International Group

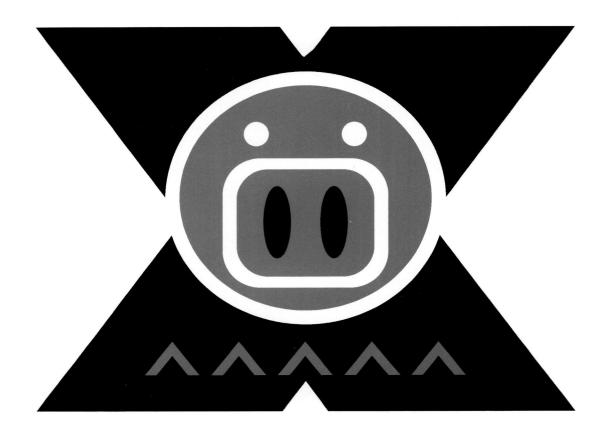

Logo for 10th annual pig roast at Wilcox Farm in Charleston, West Virginia.

Design Firm:
Phil Evans Graphic Design
Huntersville, NC
Designer:
Phil Evans
Illustrator:
Phil Evans

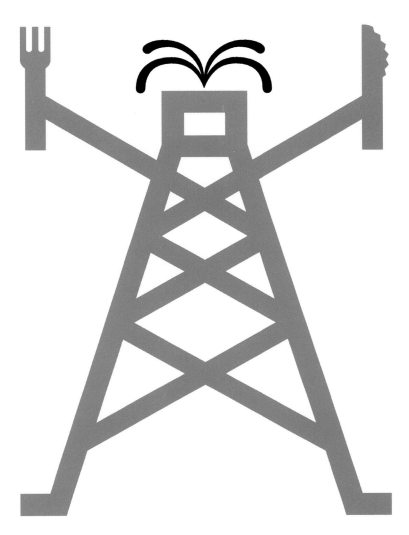

DENBURY RESOURCES INC.'98
DALLAS PICNIC '98

Logo for annual picnic for Denbury Resources, Inc., an oil and natural gas company.

Design Firm:
Eisenberg And Associates
Dallas, TX
Art Director:
Meggan Webber
Creative Director:
Saul Torres
Designers:
Meggan Webber, Cesar Sanchez

ON YOUR TOES!
Black + White Ball
415.864.6000

KICK UP YOUR HEELS!
Black + White Ball
415.864.6000

PUT ON YOUR DANCIN' SHOES
Black + White Ball
415.864.6000

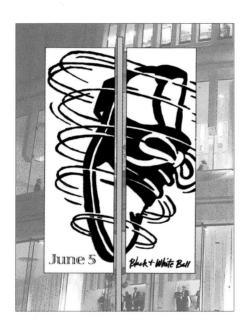

June 5 *Black + White Ball*

Symbols for a fundraising gala event for the San Francisco Symphony.

Design Firm:
Kevin Akers-Designer
San Rafael, CA
Art Director:
Kevin Akers
Designer:
Kevin Akers
Illustrator:
Kevin Akers
Photographer:
The Image Bank

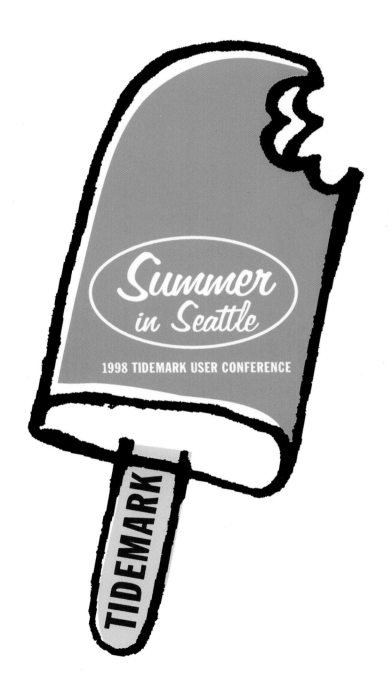

Logo for Tidemark Computer Systems' 1998 user conference.

Design Firm:
Modern Dog
Seattle, WA
Art Director:
Vittorio Costarella
Designer:
Vittorio Costarella
Illustrator:
Vittorio Costarella
Poster designer:
Robynne Raye

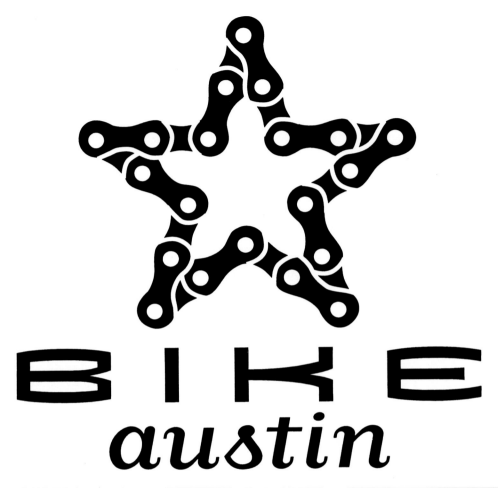

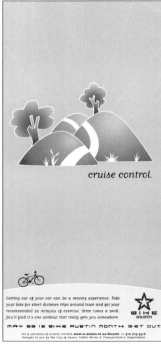

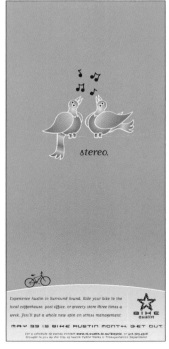

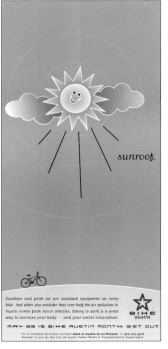

Logo for Austin Bike Month, encouraging Austin, Texas, residents to use bicycles as primary transportation.

Agency:
TKO Advertising, Inc.
Art Director:
Joshua Finto
Designer:
Joshua Finto
Client:
City of Austin Public Works & Transportation Department

Logos for a countywide series of cultural events.

Design Firm/Agency:
Steven Morris Design
San Diego, CA
Art Director:
Steven Morris
Designer:
Steven Morris
Illustrator:
Steven Morris
Client:
Arlington County (Virginia)
Arts

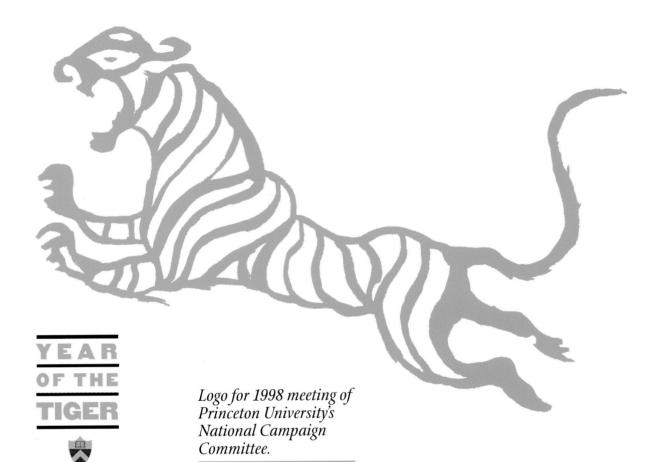

Logo for 1998 meeting of Princeton University's National Campaign Committee.

Design Firm/Agency:
ChingFoster
New Brunswick, NJ
Designers:
Donna Ching,
D. Jonathan B. Foster
Illustrator:
Donna Ching
Client:
Princeton University/
Development
Communications

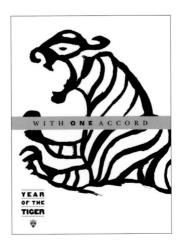

Non-profit

This section should make you feel good. That's because the designers who worked on these logos felt good about what they were doing, and that sense of well-being comes across in the finished product. Many of the designs were produced for charities, and were mostly done pro bono. It must have been pleasant for the designers to reflect that the phrase that indicates you are giving your services for free actually means "for the good." Of course, not all non-profits are charities. Gathered here we also find schools, museums, and arts organizations, most of whom paid for their logos. But even these institutions often had relatively small budgets, as well as relatively lofty agendas. Whether your design is helping to raise awareness about AIDS, or encouraging people to learn acupuncture, you can enjoy the happy knowledge that your client is helping people out.

This notion of being an agent for betterment seems to have had a definite effect on the style of the logos for charitable organizations; the images give off an air of honesty—no frills or trendy effects. That's not to say that the designs aren't clever and elegant. They often are. But the reader may notice that, for the most part, they have a simpler look than those for the schools and museums, which employ more detailed, illustrative styles.

One odd attribute of the latter group is the prevalence of animal imagery. A small cross-section of the wild kingdom appears here to represent the interests of education and charity. Sunspots Creative offered its client, an acupuncture school, the stylized image of a porcupine to whimsically represent the prickly discipline. The school embraced the idea, which allowed it to diverge from the symbols of other acupuncture schools that tended to highlight Chinese symbols of one sort or another. The Cazenovia Public Library already had a pet idea for their logo. They wanted a cat, of an Egyptian caste. Though the library has only a small museum collection, it does own two mummies, one of which is a cat. Elizabeth Jowaisas combined stock and stamp art to produce a smiling, sun-haloed Egyptian feline for the museum's logo.

In the world of charities, mummification for cats is not an end to be desired. Though the logo for Good Mews, a "no cage, no kill" shelter for cats, also features a stylized cat with a halo, the motivation here is slightly different. Starkwhite, the design company that produced the logo, aimed to replace the shelter's existing, cutesy logo with a more sophisticated one that would "raise the image of the organization from grass roots to influential community service." By turning a lower-case *g* into a curly-tailed, pointy-eared kitty, the designers achieved their goal, and, happily, bolstered the organization's funds. A regular $25 contributor wrote a letter praising the new look, and instead of his usual amount, enclosed a check for $1,000.

Starkwhite's logo not only made money, it cost their client nothing. Sometimes a cause is so appealing that designers are glad to offer their services free of charge. "In an effort to give back to the community, and to support the efforts of Sister Teresa McElwee, I did this logo pro bono," says Joe Krawczyk, who created the logo for GROWS Literary Council, which promotes literacy among Florida farmworkers. Perhaps his good intentions elicited aid from a higher authority: He says his solution, a combination pencil and book, was his very first idea. Anne Toomey and Gina Linehan at Epstein Design Partners didn't design their ParkWorks Cleveland symbol for free, but they discounted their services and feel great about being able to support a non-profit that installs inner-city parks and generally beautifies the city of Cleveland. "It's always satisfying to be involved with an organization such as ParkWorks," they say. Further proof that doing good feels good.

Of course, some people don't feel good unless they feel bad . . . very, very bad. This introduction could not close without a brief mention of one of the less prosaic non-profits herein, the Seattle Kink Information Network (SKIN). Art Chantry did not have the subject matter advantages of other non-profit designers when designing for this S&M information service—no trees, books or cats for him. He states, "I had to convey the organization's intent and interests without going over the edge into clichés or pornography." While he declines to share the ideas he discarded ("Not in mixed company," he says), his final logo, the acronym in white against black, "bound" with black lines, is smart, elegant, and actually inoffensive. And he did it for only $50.

Logo for the Southern Arizona AIDS Foundation.

Design Firm:
Hoffman Design
Tucson, AZ
Art Director:
David E. Hoffman
Designer:
David E. Hoffman

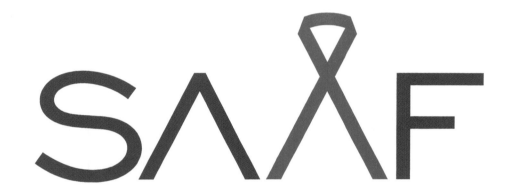

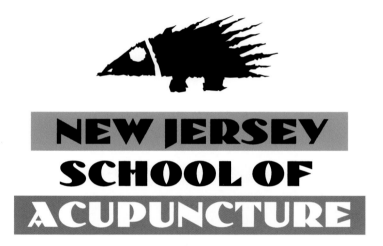

Logo for the New Jersey School of Acupuncture.

Design Firm:
Sunspots Creative, Inc.
Hoboken, NJ
Art Director:
Rick Bonelli
Designers:
Deena Hartley,
Rick Bonelli

Logo for a Christian arts organization.

Design Firm:
Frank D'Astolfo Design
New York, NY
Art Director:
Frank D'Astolfo
Designer:
Frank D'Astolfo

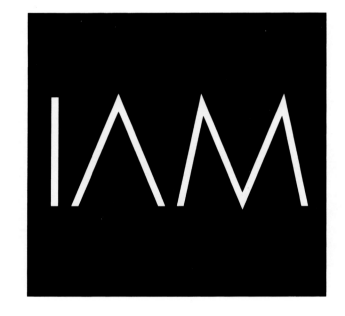

Logo for a network that disseminates information about sado-masochism.

Designer:
Art Chantry
Seattle, WA

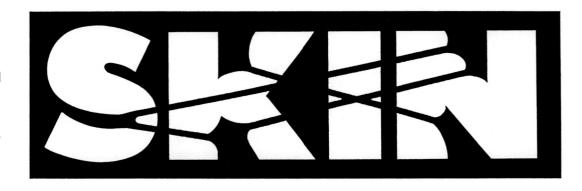

*Logo for Riverplace
Community Garden.*

Design Firm:
John Bowers
Portland, OR
Art Director:
John Bowers
Designer:
John Bowers

good **g** mews

*Logo for a no-kill,
cage-free shelter for cats.*

Design Firm:
Starkwhite
Decatur, GA

TULSA PARKS

Logo for Tulsa Parks and Recreation Department.

Design Firm:
Walsh Associates
Tulsa, OK
Art Director:
Kerry Walsh
Designer:
Dan VanBuskirk
Illustrator:
Dan VanBuskirk

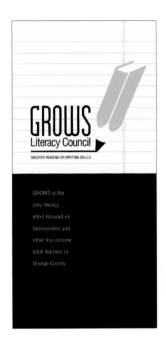

Symbol for Greater Reading or Writing Skills Literary Council, an organization promoting literacy among Florida farmworkers and other low-income workers.

Design Firm:
Corporate Design Associates
Orlando, FL
Creative Director:
Joe Krawczyk
Designer:
Joe Krawczyk

Logo for the Women's Studies program at Bowling Green State University.

Design Firm:
UniGraphics
Bowling Green, OH
Art Director:
Paul Obringer
Designer:
Paul Obringer
Illustrator:
Paul Obringer

*Logo/masthead for
AIGA Atlanta's fax
publication.*

Design Firm:
Office of Ted Fabella
Atlanta, GA
Art Director:
Ted Fabella
Designer:
Ted Fabella

NIGHT SHIFT

FIRST DOODLE
WHILE I SPOKE
TO ART DIRECTOR
↓

1.

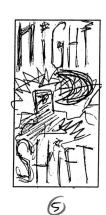

2.

3.

4.

5.

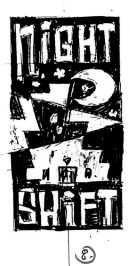

6.

LAYING OUT SPACE / DESIGN

7.

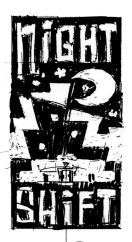

8.

9.

10. I

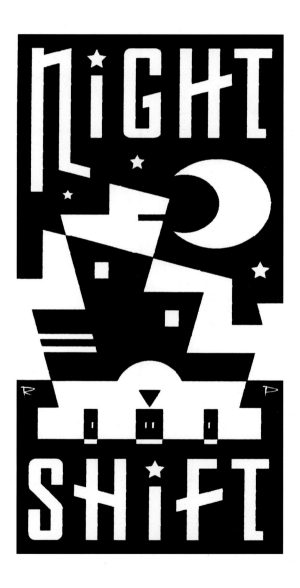

Logo for a column appearing in The Wall Street Journal.

Design Firm:
Robert Pizzo
Redding, CT
Art Director:
Claudia Waters
Illustrator:
Robert Pizzo
Client:
The Wall Street Journal

Logo for an editorial piece, "Taking Aim At International Arms Control," covering gun control around the world.

Design Firm:
Communication Arts
Associates
Richmond VA
Art Director:
Doug Malott
Designer:
Doug Malott
Illustrator:
Lauren Cross
Client:
Issue/Action Publications

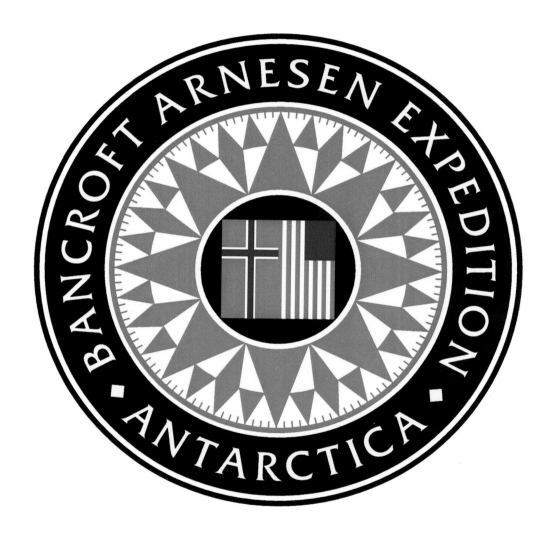

Logo for the first all-women's expedition across Antarctica.

Design Firm:
The Office of Eric Madsen
Minneapolis, MN
Art Director:
Eric Madsen
Designers:
Eric Madsen,
Alex Bajuniemi,
Sara Leffler
Client:
Base Camp Promotions

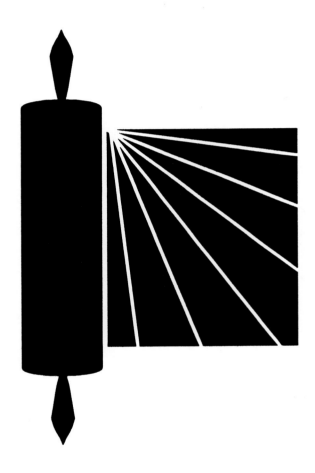

Logo for a program to champion Jewish identity on college campuses.

Design Firm:
Beth Singer Design
Washington, DC
Art Director:
Beth Singer
Designer:
Daniel Jacobs
Client:
Hillel: The Foundation for
Jewish Campus Life

Logo for a radio show.

Design Firm:
eye4 inc.
Gainesville, FL
Art Director:
Buster O'Connor
Designer:
Buster O'Connor
Client:
North Florida Regional
Center

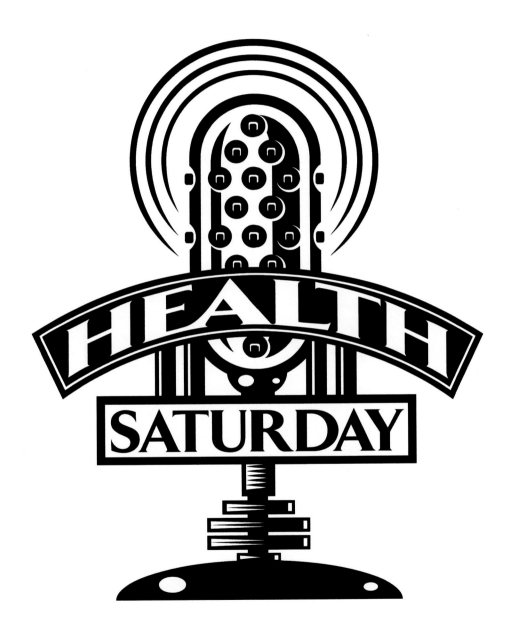

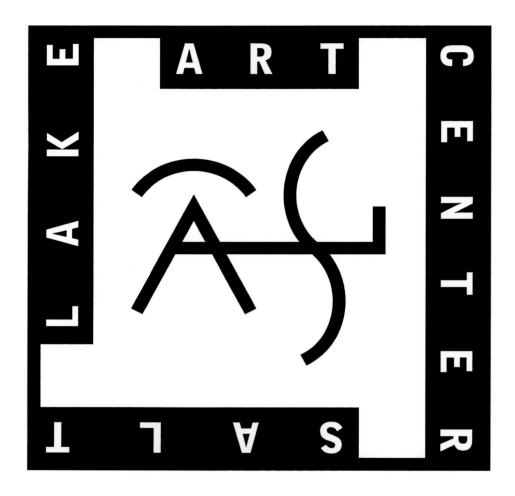

Logo for The Salt Lake Art Center.

Design Firm:
AND Design
Salt Lake City, UT
Art Director:
Scott Arrowood
Designer:
Scott Arrowood

Logo for an international non-profit organization that aims to improve the lives of children affected by poverty and conflict through sports and recreation.

Designer:
Andrea Thomas
New York, NY

Symbol for a community service organization.

Design Firm:
Tom Fowler Inc.
Stamford, CT
Art Director:
Karl S. Maruyama
Designer:
Karl S. Maruyama

Logo for an organization that provides information on creating stronger, healthier families.

Design Firm:
Michael J. O'Keefe & Associates
Oklahoma City, OK
Art Director:
Michael J. O'Keefe
Designers:
Michael J. O'Keefe, Thomas Batista
Illustrator:
Guy McAlister
Client:
Oklahoma Christian University

INSTITUTE FOR MARRIAGE & FAMILY
OKLAHOMA CHRISTIAN UNIVERSITY

Logo for a program to create links between U.S. and Vietnam art communities.

Design Firm:
eye4 inc.
Gainesville, FL
Art Director:
Buster O'Connor
Designer:
Buster O'Connor
Illustrator:
Buster O'Connor
Client:
Robert C. Sanchez, a private arts development group.

Logo for an AIDS service organization.

Design Firm:
Edward G. Buns
Columbus, OH
Art Director:
Edward G. Buns
Designer:
Edward G. Buns

**COLUMBUS
AIDS
TASK
FORCE**

Symbol for a center at Mesa Community College that provides educational services to underprivileged students in the city of Mesa.

Design Firm:
Dino Design
Phoenix, AZ
Art Director:
Dino Paul
Designers:
Tim Brewer,
Dino Paul
Illustrator:
Tim Brewer

Symbol for a program that focuses on improving the natural environment of Cleveland.

Design Firm:
Epstein Design Partners Inc.
Cleveland, OH
Designers:
Anne Toomey,
Gina Linehan
Illustrators:
Anne Toomey,
Gina Linehan

Logo for a museum in the Cazenovia Public Library.

Design Firm:
Jowaisas Design
Cazenovia, NY
Designer:
Elizabeth Jowaisas

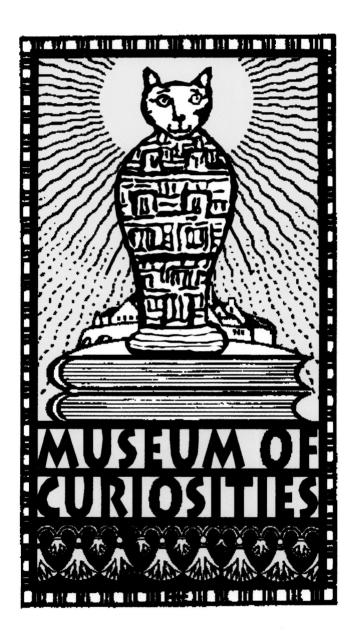

Symbol for the New Mexico Museum of Natural History's expansion fund drive.

Design Firm:
Rick Johnson & Company
Albuquerque, NM
Creative Director:
Ron Salzberg
Designer:
Tim McGrath
Copy Writers:
Ron Salzberg,
Sam Maclay

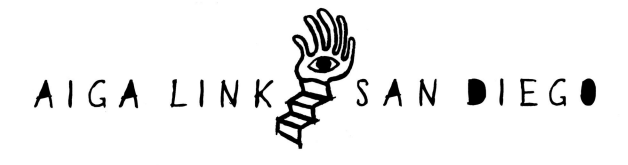

Logo for AIGA San Diego's outreach and education program.

Design Firm:
Steven Morris Design, Inc.
San Diego, CA
Art Director:
Steven Morris
Designer:
Rosa Torres
Illustrator:
Rosa Torres

Individuals

Logos designed for individuals move us to reflect on what we mean when we talk about "identity." Large companies, being what they are, may not necessarily come to the designer with a clearly defined company persona. The designer is instrumental in giving the company a "face," so that clients can feel they are dealing with a known quantity. With clients who are individuals, the designer still wants to introduce the client to the world, but the means of doing so become much more personal. There is a good chance that, instead of helping to invent an identity, the designer is projecting a defined existing personality.

Creating a logo for an individual seems to fall somewhere between authorized biography and heraldry. The design must tell viewers something true about the individual, and must stand as that person's mark, the banner that bears the person's name and visually describes his or her attributes or abilities.

Two logos in this section that really define the category were created for voice talents. Not only are these people in business by themselves, but their business is a peculiarly individual one. Few people sell anything as idiosyncratic as the human voice. Also, there's a particular design challenge attached to such a project. As Art Chantry asks, "How do you do a visual for a voice?" The answer seems to be "use the face." Both Chantry and designer Todd Coats chose the image of a face as the natural graphic representation of voice. In other respects, their approaches were widely divergent. Chantry's logo for Michael Stein, a specialist in overdubs and voice-overs, uses the face of a ventriloquist's dummy—an ideal means of visually conveying his client's line of work. The logo that Coats concocted for Mary Lou McGregor ingeniously transforms her initials into a woman's face, complete with vocalizing mouth. Coats wanted to make sure that McGregor's distinctive name got recognition, while at the same time communicating the nature of her profession. He writes that he and McGregor "briefly toyed with the idea of highlighting her German roots, but decided that that might not be an important issue for producers." Like skilled authorized biographers, the best designers know which aspects of their client should be featured, and which ones really aren't pertinent to the tale at hand.

As Coats's logo illustrates (in more ways than one), the individual's name is often the most pertinent aspect of all. Designer Lee Busch puts it best when describing his work for printer's representative Michael Witunski: "What we're selling here is a person, his unique knowledge and the positive working relationship you develop with a good sales rep. His most valuable asset is his good name." Luckily for Busch, his client's initials also presented excellent design possibilities. "*M* and *W* are symmetrical," Busch explains, "so his initials offered the opportunity to play with geometry." The designer's choice of benday dots gives the logo flair, while subtly communicating the client's trade.

Designer Bill Carson also incorporated John Carter's initial into his logo, but in a less obvious fashion. In fact, at first glance, you might think that Carson had based the logo solely on outward characteristics of the client. Carter is a writer and marketing consultant who happens to live on an 850-acre Texas ranch. Choosing to focus on this habitat fact, Carson chose an image of the property's abundant, rusted barbed-wire. Rendering his image of the wire loosely in the form of a *C* was an obvious next step. Oddly, it was a step not so obvious to John Carter, who didn't immediately see his initial in the logo (his wife did see it).

Their client's locale also motivated design team Jon and Karen Wippich when they developed a logo for accountant Jodie Day, but they had the added advantage of her evocative last name. "The fact that the client's name is Day, and she lives in Phoenix, Arizona, where it's always sunny, was too good to pass up," says Wippich. The designers used a gold-colored ink to flood the logo's field on business cards, turned the dot on the *I* into a sun, and gave the letters of Day's name long, black shadows. The client immediately warmed to the logo's friendly, professional look. From this, we can extract one simple rule for individual logo design: Throw some light on the subject.

SCOTT SHRADER

Symbol for a landscape designer and installer.

Design Firm:
Buddy Morel
Santa Monica, CA
Art Director:
Buddy Morel
Designer:
Buddy Morel
Photographer:
Buddy Morel

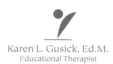

Karen L. Gusick, Ed.M.
Educational Therapist

LEARNING DISABILITIES
REMEDIATION AND ASSESSMENT
SOCIAL SKILLS INTERVENTION

5121 SOUTH ELLIS AVENUE
CHICAGO, ILLINOIS 60615
PHONE 773-643-4566
FAX 773-643-5637

Logo for an educational therapist.

Design Firm:
Murrie Lienhart Rysner
Chicago, IL
Designer:
Jim Lienhart

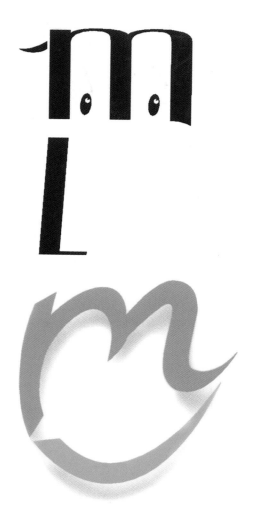

Logo for a voice talent.

Design Firm:
Tool Box
Art Director:
Todd Coats
Designer:
Todd Coats
Illustrator:
Todd Coats

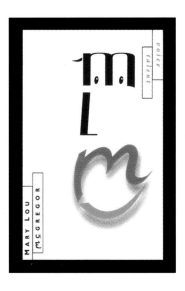

Logo for the personal correspondence of Clive and Jane Cochran. Not a product label.

Design Firm:
Mithoff Advertising
El Paso, TX
Designer:
Clive Cochran

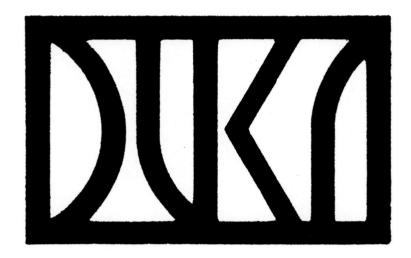

**LONNIE DUKA
PHOTOGRAPHY**

352 THIRD STREET
SUITE NUMBER 304
LAGUNA BEACH
CALIFORNIA 92651
TEL 714 494 7057
FAX 714 497 2236

Logo for a photographer.

Design Firm:
Michael Dula Design
Irvine, CA
Creative Director:
Michael Dula
Designer:
Michael Dula

THE CARTER RANCH

*Logo for a writer/
marketing consultant
who lives on a ranch.*

Design Firm:
Bill Carson Design
Austin, TX
Art Director:
Bill Carson
Designer:
Bill Carson
Illustrator:
Bill Carson

Logo for a printer's representative.

Design Firm:
Lee Busch Design
Somerville, MA
Designer:
Lee Busch

Logo for Jodie Day Accounting & Tax Preparation.

Design Firm:
Dotzero Design
Portland, OR
Designers:
Karen Wippich,
Jon Wippich

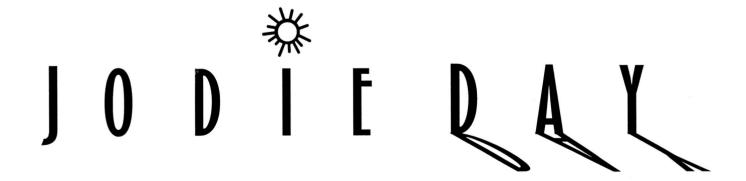

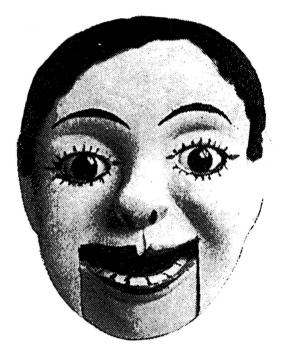

Michael Stein

Voice "Talent"

Logo for a voice talent.

Designer
Art Chantry
Seattle, WA

*Logo for a film director
based in Houston, TX.*

Design Firm:
Rigsby Design
Houston, TX
Art Director:
Lana Rigsby
Designers:
Thomas Hull,
Amy Wolpert
Illustrators:
Andy Dearwater,
David Bowman

Logo for a copywriter.

Design Firm:
The Morris Group
Altadena, CA
Creative Director:
Ronald Morris
Designer:
Chanolara Lim

Technology

These days, it's a given that the vast majority of graphic designers rely heavily on computer technology. Even the most lovingly hand-drawn illustration ends up being manipulated on-screen, and then perhaps sent on its way to the client via PDF. Considering the tighter deadlines, computer-failure panics, and software expenditure resulting from this new dependence, some designers might wonder whether they're working for technology rather than technology working for them. For the designers in this section, there's no question about it: They are working for technology, or at least, for purveyors of technology. Their clients are the companies that orchestrate the many aspects of Internet business, make software, and even offer aid to those of us who spend more time cursing at a computer than actually using it.

The distinguishing feature of these logos and symbols is that many of them needed to work as well on a Web page as on the pages you have just been turning. This was the case with Mike Tomko's logo for Archive Access, a Web-based asset management company that stores and transfers data. His capital *A*, formed of floating dots, successfully leads a double life on paper and screen. For business cards and letterhead, the logo was laser-cut into the paper, which has a metallic ink backing, giving these pieces a sharp, almost futuristic look. The rounded, mercury-like dots he employed for the Internet treatment manage to convey the same esthetic, but in a form more appropriate to the digital medium.

Tomko's was one of a couple logos that also function as navigational elements in multimedia and Web applications. Travis Tom's series of symbols for Orbit Network, which caters to the travel industry on-line, help direct browsers around Orbit's site, and communicate the subject matter of the Web site's various sections. "I was given a word or name for each section," he says, "and I designed an icon to reflect each word." Though the icons were designed primarily with their digital application in mind, Tom says that they could easily make the transfer to sales collateral and newsletters. The road-sign simplicity of the icons emphasizes their purpose, while making their dual application more feasible.

"Abstract" and "sharp" certainly seem to be the characteristics of the tech logo. It's notable that the only hand-illustrated logo in this group belongs to Client Net, a Web-based offshoot of advertising agency Miller/Huber. Perhaps the client's less tech-y nature allowed for this loose, radiographed cartoon of an armchair-seated computer viewer. Another vaguely figural logo in this group caters nonetheless to a cyber sensibility. Hornall Anderson's symbol for Personify, a software company that creates databases for on-line sales businesses, renders a fedora hat abstractly, and centers it within the brackets one now associates with coding.

Other companies here made specific requests for logos that would fly in cyberspace. Take, for instance, the logo for CST's Web-based technical support software, Rescue. The company's original logo featured a St. Bernard dog with the traditional barrel of whisky around its neck. CST asked David Roberts of FGI, Inc., for "a more corporate identity that better communicated a digital environment, but still maintained an active sense of 'rescue.'" Roberts' final symbol, a ladder that appears to be building on itself, is a more up-to-date approach to the theme, and one which, again, is suitable for use in a digital context.

Computer Consultants Group, which assists its clients with system configuration, Internet access and trouble-shooting, also asked for a "technical identity" when they approached Gil Shuler Graphic Design. While Shuler took this request under advisement, endeavoring to create a cyber-friendly logo, he also considered the outlook of CCG's clients. "We assumed that these people knew nothing about computers," he says. "As far as they knew, a spring could pop loose, like it would from a watch." Keeping the loose-spring theory of computer ailments in mind, he designed CCG's logo: two *C*'s and a *G* which together make up the coils of a spring. It seems as if Shuler's idea for the logo probably sprung, so to speak, from his own experience as a computer user. At least, it seems safe to assume this, given the nature of the budgetary information for the project: Shuler traded the design for his client's services. Do not be surprised to see more of this kind of arrangement in the future.

Logo for a computer consultant.

Design Firm:
Gil Shuler Graphic Design
Charleston, SC
Art Director:
Gil Shuler
Designer:
Gil Shuler

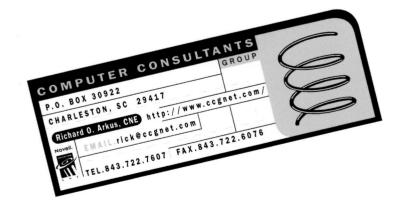

RESCUE

*Logo for creators of
Web-based, technical
support software.*

Design Firm:
FGI, Inc.
Chapel Hill, NC
Art Director:
David Roberts
Designer:
David Roberts
Illustrator:
David Roberts
Client:
CST

Logo for Miller/Huber's Internet system for clients wishing to check the status of a job.

Design Firm:
Miller/Huber Relationship
Marketing
San Francisco, CA
Art Director:
Paul Huber
Designer:
Ward Schumaker
Illustrator:
Ward Schumaker

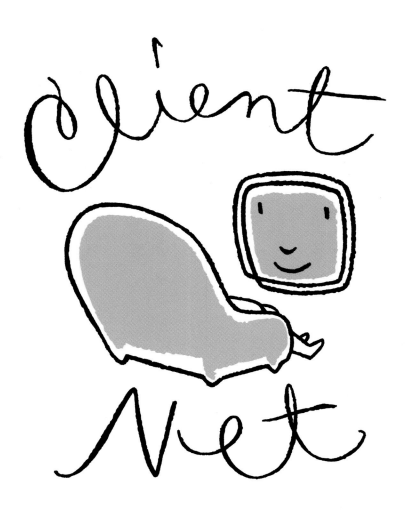

PERSONIFY

Logo for a manufacturer of software used to create customized databases for on-line sales companies.

Design Firm:
Hornall Anderson Design Works
Seattle, WA
Art Director:
Jack Anderson
Designers:
Jack Anderson,
Debra McCloskey,
Holly Finlayson

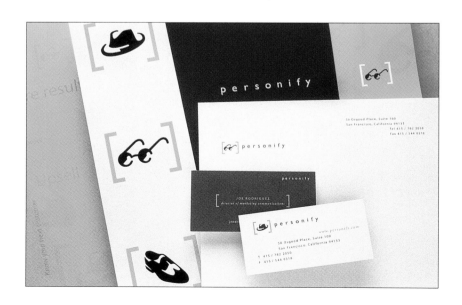

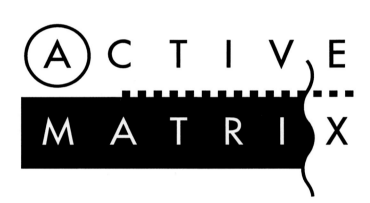

Logo for a Web-based software program aiding large corporations to plan meetings.

Design Firm:
Taylor Design
Stamford, CT
Art Director:
Daniel Taylor
Designer
Jennifer Whitaker
Client:
SCLMS Software

Logo for an electronic asset management service.

Design Firm:
CFD Design
Phoenix, AZ
Art Director:
Mike Campbell
Designer:
Mike Tomko

ORBIT NETWORK, INC.

alliances

software

history

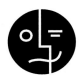

people

client list

finances

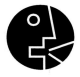

customers

creative services

initiatives

marketing

operations

sales

Icons for a company that creates and supports distribution channels for consumer and travel buyers with an on-line presence.

Design Firm/Agency:
Orbit Network Inc., Creative Services
Novato, CA.
Art Director:
Chris Howerdd
Designer:
Travis N. Tom
Illustrator:
Travis N. Tom

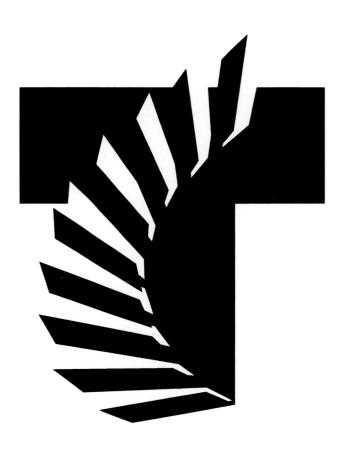

Logo for a Webmaster for high-tech clients.

Design Firm:
Z Design
Olney, MD
Art Director:
Irene Zevgolis Christian
Designer:
Irene Zevgolis Christian

Logo for a company that wires individual homes or community housing developments to the Internet.

Design Firm:
Walker Creative Inc.
Oklahoma City, OK
Designer:
Steven Walker
Illustrator:
Steven Walker

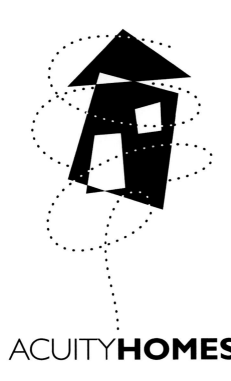

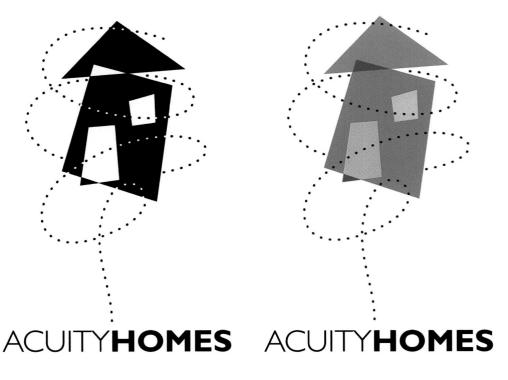

ACUITY**HOMES** ACUITY**HOMES**

talk2·

Logo for a voice recognition-based Internet service provider.

Design Firm:
Gillett + Co.
Salt Lake City, UT
Art Director:
Eric Gillett
Designers:
Eric Gillett,
Brent Barson

Logo for creators of graphing software.

Design Firm:
SGL Design
Phoenix, AZ
Art Director:
Steve Smit
Designer:
Andrew Harrison

FlyBase

Logo for a database for information on the genetics and molecular biology of fruit flies.

Design Firm:
The Salamander
Berkley, CA
Director:
Grégoire Vion

FLYBASE

FLYBASE

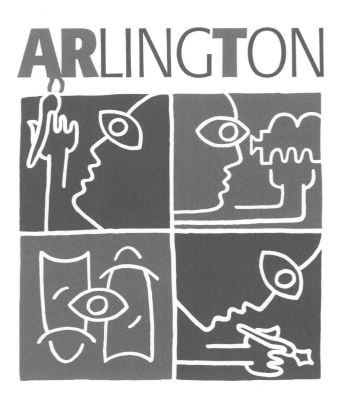

Icons for Arlington County (Virginia) Arts' website.

Design Firm/Agency:
Steven Morris Design, Inc.
San Diego, CA
Art Director:
Steven Morris
Designer:
Steven Morris
Illustrator:
Steven Morris

*E*ntertainment

If one were to choose a single adjective to describe this year's entertainment logos, it would be "dynamic." Not only do these logos convey the life and vigor of the entertainment world, but a couple of them might actually *move*: Signal Communications' logo for Picture Factory and Graphic Garden's logo for Cherry Pie Productions were created with animation in mind.

Of course, when it comes to putting the motion in graphics, one surefire way is to use the image of a dancer. For his client, Choreo Collective, David Ferris made studies of the group's dancers in action. But when it came to incorporating them into a logo, he felt his sketches were "too obvious, or didn't have the right feel." To solve this problem, he meshed his drawings with his other idea: an arrangement of the multiple *C*s in his client's name. This lent his leaping dancer a heightened sense of motion, by way of the trailing, bubble-like *C*s, and gave the image a fresh spin.

The logo for Motion Underground's "Blue" show incorporates the movements of dance rather than an actual dancer. It tops each letter of the word "blue" with swirling red arrows indicative of basic dance moves. Coming up with this concept was the easy part for designer James Kovac. "The largest problem was convincing [the dance company] that a logo was needed," he states. Apparently, the group wanted a poster and a "look," but feared that a logo would make them appear "corporate." Kovac's design has convinced them, however, that a logo can express any sensibility; they are now working with him to generate a logo and signage for their studio.

Not all entertainment clients are ambivalent about their logos. Alex Ganza of Cherry Pie Productions knew that he wanted a whimsical identity that would communicate his own quirky approach to television writing and production. He immediately seized on Dianne Bennett's punning hieroglyphic, which combines the image of a cherry with the "pi" symbol. According to Bennett, Ganza was a dream client: "This project was a piece of cake," she says, "or should I say, pie!"

A good client can be an inspiration; so can a client's business, if that business happens to be the production of a Pulitzer Prize–winning play. Stella Bugbee, of Spot Design, had the enviable task of creating a logo for the Off-Broadway production of the play Wit. Bugbee and art director Drew Hodges cleverly incorporated a semi-colon, a pivotal symbol in the play, into the title. "The play is both serious and funny, tragic and uplifting, but overall very literary," say the designers. "We needed a logo that worked without a photo to communicate the literary twist."

Designer Derek Sussner also wanted to provide a twist. His client, Twist Film Productions, requested a logo that included the company's name and illustrated the nature of the business. With a word like twist, one can imagine that the solutions seemed endless. Sussner eliminated everything from bottle caps to the '50s dance craze, until he settled on his series of turning letters in circles with "twist this way" directional arrows. Sussner's solution, which also allows for future animation, shares a quality with the logos mentioned here, in that it combines a sense of humor with a sense of action to get its point across. This same combination is often used to good effect in the world of entertainment, proving that, when it came to understanding their clients' needs, Sussner and the other designers in this section had all the right moves.

Logo for video and film producers.

Design Firm:
Signal Communications
Silver Spring, MD
Creative Director:
Scott Severson

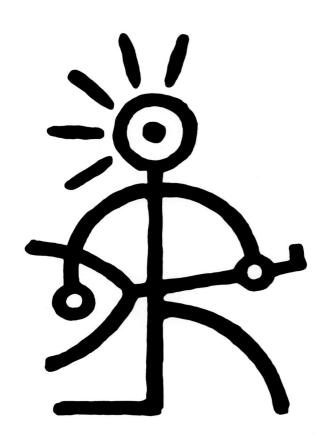

Logo for a writer and publisher of lyrics.

Design Firm:
Deep Design
Atlanta, GA
Designer:
Rick Grimsley

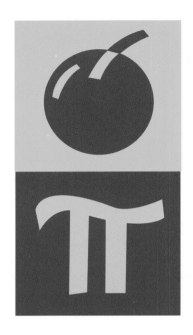

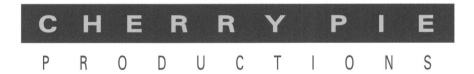

*Logo for a television
production company
headed by writer/
producer Alex Ganza.*

Design Firm:
Graphic Garden
Ventura, CA
Designer:
Dianne Bennett
Illustrator:
Dianne Bennett

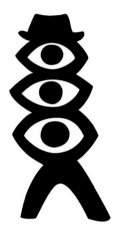

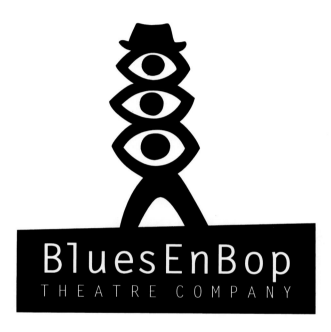

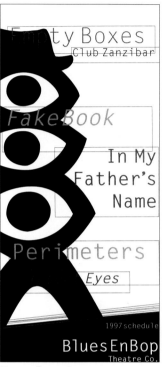

Logo for a jazz-influenced, multi-ethnic theater group.

Design Firm:
S Adrian Design
New York, NY
Art Director:
Susanne Adrian
Designer:
Susanne Adrian
Illustrator:
Susanne Adrian

THE MATRIX

Logo for a hit Warner Brothers' film.

Design Firm:
Girvin, Inc.
Seattle, WA
Art Director:
Tim Girvin
Designer:
Miles Matsumoto
Illustrator:
Tim Girvin

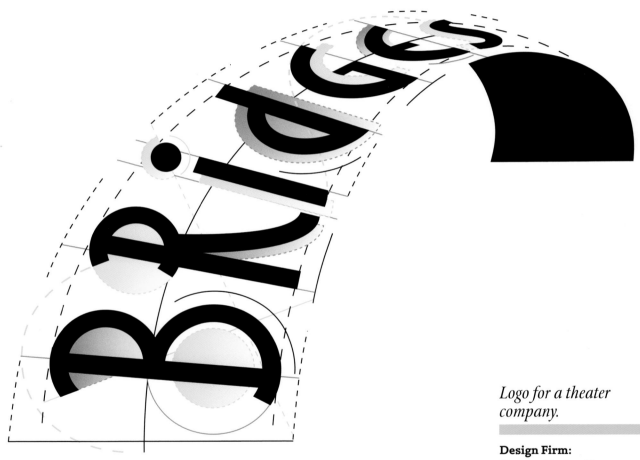

Logo for a theater company.

Design Firm:
Hansen Design Co.
Seattle, WA
Creative Director:
Pat Hansen
Designers:
Carrie Adams,
Bob Perlman
Illustrator:
Carrie Adams

B L U E

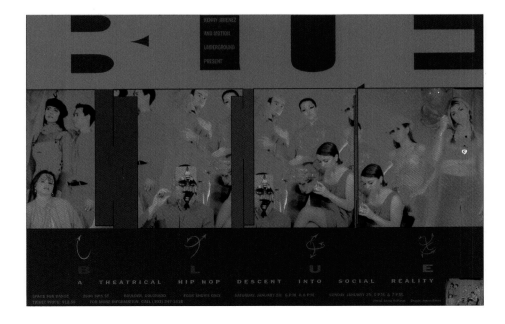

Logo for a dance troupe and experimental dance studio.

Design Firm:
Kovac Design
Denver, CO
Director:
James Kovac

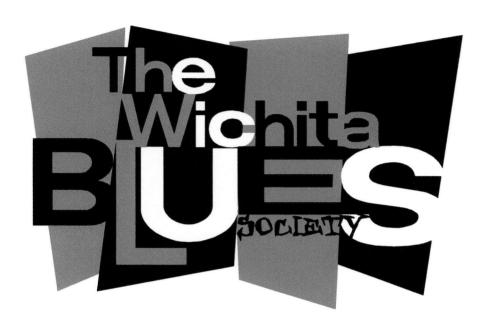

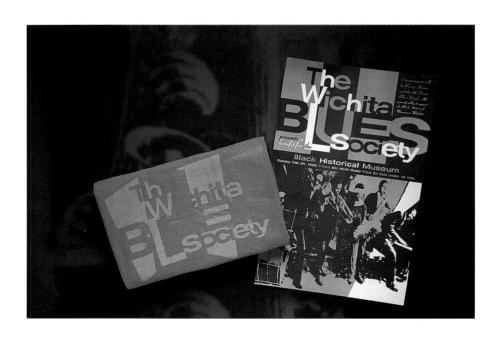

Logo for an organization of musicians and supporters of blues music.

Design Firm:
Dotzero Design
Portland, OR
Designers:
Karen Wippich,
Jon Wippich

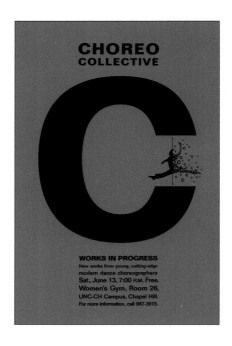

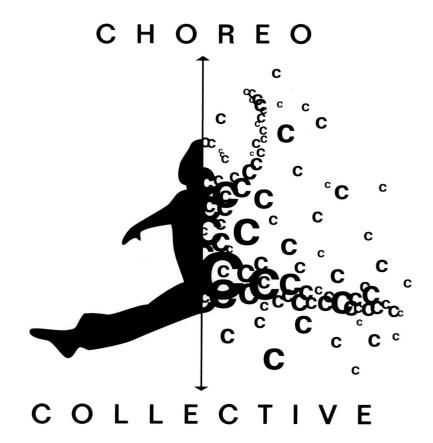

Logo for a group that helps modern dancers and choreographers share and develop their work.

Design Firm:
David N. Ferris
New York, NY
Art Director:
David N. Ferris
Designer:
David N. Ferris
Illustrator:
David N. Ferris

Logo for a firm headed by screenwriter Denis O'Neill

Design Firm:
Rebekah Beaton Design
Calabasas, CA
Designer:
Rebekah Beaton

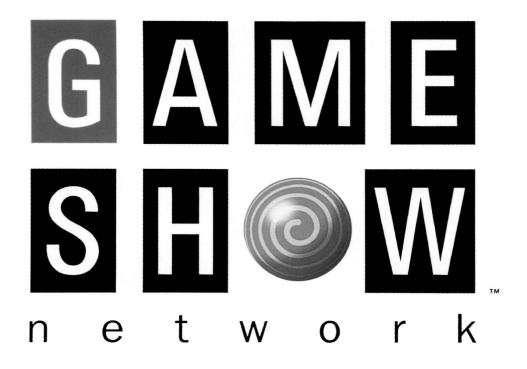

Logo for a cable network.

Design Firm:
Lee Hunt Associates
New York, NY
Executive Director of Design:
Jill Lindeman
Project Manager:
Elena Olivares
Design Director:
Cheri Dorr
Designer:
Colleen Bothwell
Clients:
(Game Show Network)
Caroline Beck,
Elaine Parrish,
Dena Kaplan

Logo for a record label.

Design Firm:
Art Chantry
Seattle, WA
Designer:
Art Chantry
Client:
Michael Stein/
Chuckie–Boy Records

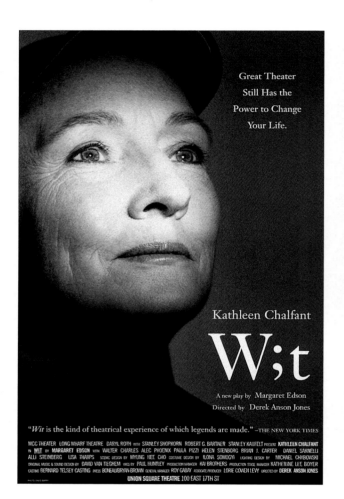

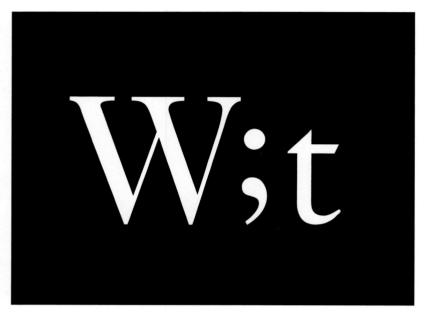

Logo for the Off-Broadway play.

Design Firm:
Spot Design
New York, NY
Art Director:
Drew Hodges
Designer:
Stella Bugbee
Client:
MCC Theater,
Long Warf Theater,
Daryl Roth, with
Stanley Shopkorn,
Robert G. Bartner,
Stanley Kaufelt

Symbol for a film production company.

Design Firm:
RBMM
Dallas, TX
Art Director:
Jackson Wang
Designer:
Jackson Wang
Illustrator:
Jackson Wang

Logo for a firm of directors and producers of television commercials.

Design Firm:
Sussner Design Company
Minneapolis, MN
Principal:
Derek Sussner

 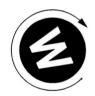 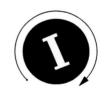 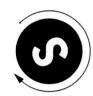 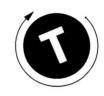

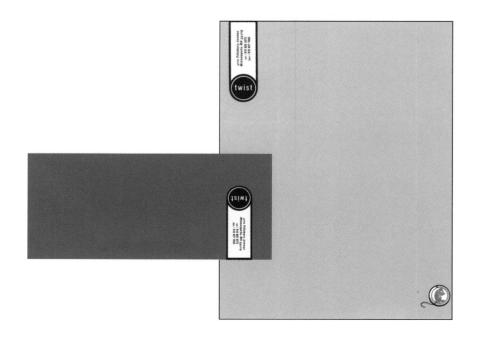

Products & Manufacturers

How do you make a logo that will sell a product? Answering that is about as difficult as coming up with a salable product in the first place. But undoubtedly the key to a good logo lies in the product itself. This piece of wisdom may seem obvious, but the ways in which the designers in this section interpret it is not. Many subjected their clients' products to a design-oriented scrutiny, and in the process discovered the linchpin of their logos.

A prime example of this approach is Thompson & Company's design for the Delta Beverage Group, a soft drink distributor. The company already had a logo, an "abstract, '70s-style symbol," in the words of the designer, that was no longer relevant to the company's image. The solution for the new logo came to art director Rick Baptist while he was drinking a soda: He noted that the can tab already contained the letter *D*, and that a *B* could easily be tweaked out of the existing form. One photograph and a little retouching later, and Delta's updated logo was in place.

Jan Bertman also took inspiration from her client's product, though in a slightly less direct fashion. The logo she created for Montalvo Gardner, a company that designs custom rugs, takes the rug as its format. The hand-drawn type, placed within an irregular border, becomes the carpet's design; the edges of the rug are defined by the logo's square, black field, and the border of the logo becomes the carpet's border.

While it behooved these designers to transform their client's products into viable logos, one design firm practically made its own new product in order to achieve the same goal. RBMM, while designing the logo for Bear Creek Woodworks, ended up actually doing some woodwork so as better to understand the form chosen for the symbol. Rather than just dreaming up a wooden bear via software, the firm made an actual model out of wood, to get the look just right.

Rory Myers didn't need to get out the tools to produce his imagery for Jamie's Kids, representatives of children's clothing manufacturers. He was able to buy his visuals at Toys 'R' Us. For $2.95, he bought alphabet blocks to replace the company's existing logo, which was set in an italic font and conveyed little about his client's business. As Myers had no photography budget, he scanned the blocks directly into the computer as art, creating the stacking and shadow effects digitally.

Myers had the right idea when he used an item identified with his client's milieu as part of the logo. That's one way to create the right feeling around a product. Another is to conjure up a positive name and image the client's customer can identify with. Two companies featured here picked names to bring out the deity in their female customers, and the designers created suitably strong and edgy visuals to get the message across. For swimwear company Dive Goddess, designer John Buell aimed for something "sassy and irreverent, but feminine." His solution is a simple silhouette of a mermaid—with attitude. The ethos that needed to be conveyed for Running Goddess Dresses was similar: funky but feminine. Jim Jacobs drew his symbol for Running Goddess Dresses over his lunch hour, with what you might call fantastic results. According to the client, she had developed the name for her new line of clothing after having a dream in which she saw Jacobs' design, weeks before she and the designer even met.

Prophetic dreams are one means of predicting the success of a product logo. For another measure of divining design kismet, we turn to Rick Yamauchi's client, Oakley, Inc. This maker of eyewear and apparel needed a new spin on its signature *O*, to be applied only to items worn by professional athletes. Through extensive experimentation onscreen, bitmapping the original logo in various settings, Yamauchi produced the jagged, energetic solution that appears here. This was where the client's test-for-success came into play: If his arm hair stands on end when he sees the design, then it's the right one. Needless to say, Yamauchi's icon passed muster. In an age of polls and carefully measured demographics, it's nice to know that some people still pay heed to gut—or hair—reaction.

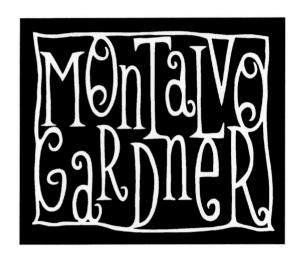

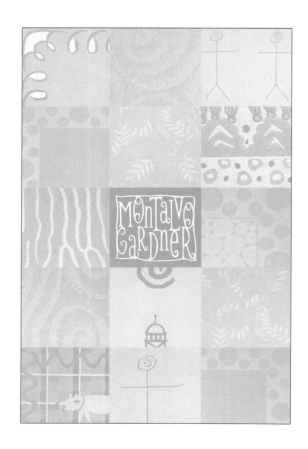

Logo for a company that designs upscale rugs.

Design Firm:
Bertman Design Studio
New Orleans, LA
Designer:
Jan Bertman

DELTA BEVERAGE GROUP

Logo for bottlers and distributors of Pepsi products and other soft drinks.

Design Firm:
Thompson & Co.
Memphis, TN
Art Director:
Rick Baptist
Creative Director:
Trace Hallowell
Associate Creative Director:
Rick Baptist
Photographer/Retoucher:
Davidson & Co.

*Logo for a manufacturer
of wooden furniture.*

Design Firm:
RBMM
Dallas, TX
Art Director:
Jackson Wang
Designer:
Jackson Wang
Illustrator:
David Vaught

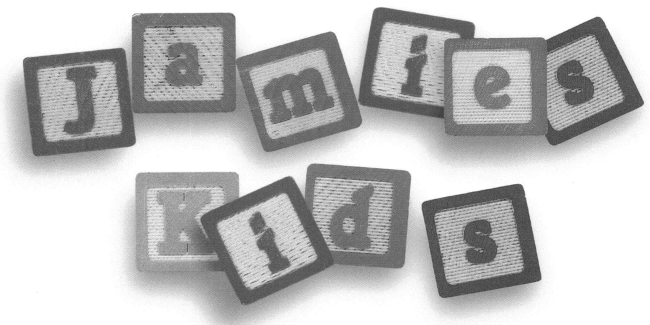

Logo for a representative of children's clothing manufacturers.

Client:
Matthew Porter
Design Firm:
Rory Myers Design
Atlanta, GA
Art Director:
Rory Myers
Designer:
Rory Myers

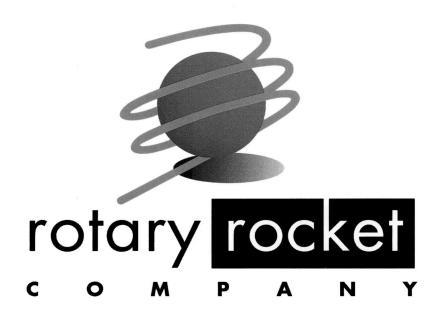

*Logo for a company that
is building a rocket to
launch satellites into orbit.*

Design Firm:
Cherk Design
San Francisco, CA
Designer:
Jennifer Cherk
Illustrator:
Jennifer Cherk

Logo for a vineyard.

Design Firm/Agency:
RBMM
Dallas, TX
Designer:
Tom Nynas

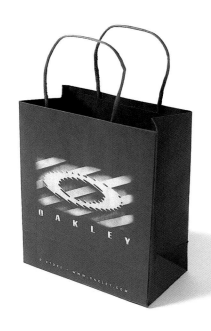

Logo for a new line of Oakley eyewear and apparel, to be worn only by professional athletes.

Design Firm:
Oakley Design
Foothill Ranch, CA
Art Director:
Rick Yamauchi
Designer:
Rick Yamauchi

Logo for a new line of women's casual apparel.

Design Firm:
RBMM
Dallas, TX
Art Director:
Jim Jacobs
Designer:
Jim Jacobs
Illustrator:
Jim Jacobs

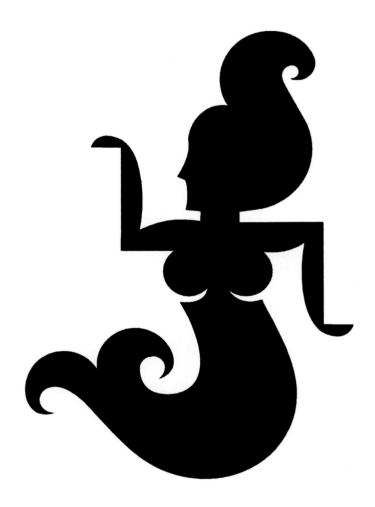

Symbol for a manufacturer and designer of women's dive wear.

Design Firm:
Buell Design/
Joseph Rattan Design
Dallas, TX
Art Director:
Joseph Rattan
Designer:
John Buell
Illustrator:
John Buell

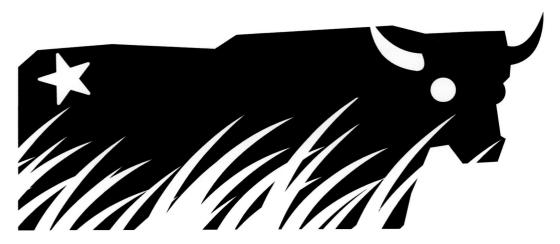

Logo for a company that raises free-range beef.

Design Firm:
Gardner Design
Wichita, KS
Art Director:
Bill Gardner,
Brian Miller
Creative Director:
Bill Gardner
Designers:
Bill Gardner,
Brian Miller

Logo for a maker of products for expectant mothers.

Design Firm:
Fuszion Art & Design
Alexandria, VA
Designers:
Richard Lee Heffner,
Anthony Fletcher

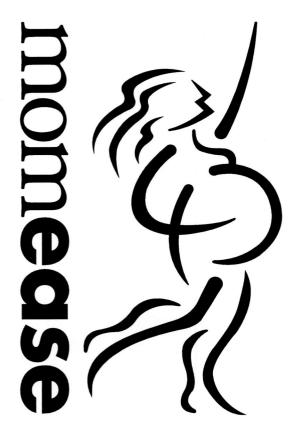

Logos for BJ Services' new line of trucks.

Agency:
Pennebaker.LMC
Houston, TX
Designers:
Greg Valdez
Illustrator:
Greg Valdez
Client:
BJ Services & Technology
Center

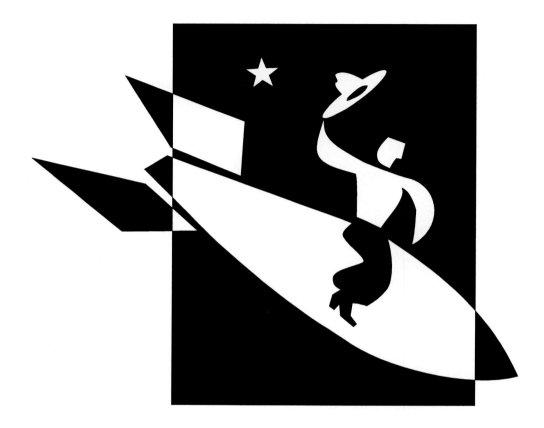

*Logo for a manufacturer
of cardiovascular
catheters.*

Design Firm:
Design Center
Minneapolis, MN
Art Director:
John Reger
Designer:
Cory Docken
Illustrator:
Cory Docken

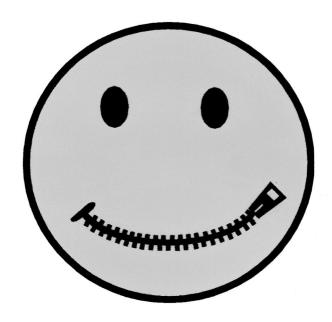

*Logo for Motorola's
internal campaign
against information
leaks.*

Design Firm:
AM Design
Chicago, IL
Client:
Motorola
Art Directors:
Monica McFadden,
Annette Rapier
Designer:
Annette Rapier

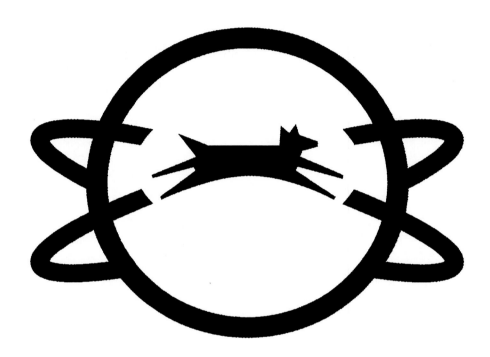

Logo for a protein supplemental dog food

Design Firm:
Prejean Creative
Springfield, MO
President:
Kevin Prejean
Agency:
The Marlin Company
Creative director:
Michael Stelzer

Design

Nothing says quite so much about a designer as his own logo. After all, no one is more keenly aware than the designer of a logo's ability to make (or even break) a business; and when the business is a design firm, the proposition becomes even trickier. The logo must speak eloquently of the designer's own abilities, qua designer; it often needs to involve the firm's name in some form; and ultimately, it is an expression of the designer's personal understanding of what design means.

It's a telling sign that no other section of this book elicited more detailed discussion of process than this one. Almost everyone here has a story, about the nightmare of being your own client; about the joy of being your own client; about that "Eureka!" moment in the shower when the solution hits you; about the varied incarnations your logo had to go through before finally blossoming into the one shown here. If, indeed, the self-promotional logo offers us an insight into the designer's methods, it is probably nothing to what designers learn about themselves while solving this single—and singular—design problem.

Larry Hanes certainly found himself reexamining the impetus behind his business when he developed the logo for his firm Design Phase. The logo had to replace the original one, which had used the name "Birdland Design," and had been strictly typographic. He says the old title confused clients, as it gave no indication of what he actually did, namely completing the "design phase" of projects. The new name and logo, he decided, must better express his approach. "I wanted my logo to convey some sort of concept/visual pun," he says. "I did not want it to reflect any strong style or trend. It needed to be very simple, classic—very vanilla. I would save the strawberry and the mint-chocolate chip for my client projects." Hanes started by making a list of words that could be used for the name, such as "simplicity," "function," and so forth. In the end, though, he came up with both name and visual concept all at once while out driving (apparently this moment of truth caused him to swerve on the road). The final logo employs an appropriate name, and uses a moon phase as the initial *D*.

Jing Tsong and Mike Austin at Hothouse Design+Advertising went through a similar process, changing both their name and their look. They say that the redesign has been so successful with clients that they're thinking of overhauling their identity once every three years, like Madonna. "People seem to enjoy a faster rate of change these days," they say. Originally called "Jing+Mike Co.," they found themselves in need of a less limiting name as the business grew. They wanted something more inclusive, less specific, something that would be accepted by a wide range of clients, yet still project the firm's edgy, irreverent attitude. Much like Hanes, they decided on a simple, clean design that had wide appeal. The red, glowing house is witty and iconic, and complements the straightforward black sans-serif typeface used for the name. "We wanted something neutral and therefore completely open," says Tsong. "We played with the photographic images of Monopoly game board houses and different illustrative styles, but we eliminated those ideas because they carried too much baggage."

This issue of a "neutral" or "classic" design was brought up by David Hoffman as well. "You don't want a logo so overdesigned that it pigeonholes the designer in a certain style," he states. Hoffman also settled on a spare, modern, playful look, using only his last initial and two colors, white and orange. Arriving at this solution, however, proved a grueling experience. Hoffman says he spent several years experimenting with logos for his business. He's not alone. Jeff Fisher took ten years to complete his visual identity, and has even developed an illustrated timeline to explain the whole long, strange trip from rough sketch of a steam engine to shiny new "Jeff Fisher LogoMotives" train. Both Hoffman and Fisher describe the process in terms usually applied to military campaigns and Arctic treks. "I tortured myself with hundreds of different directions," says Hoffman. And Fisher, queried on the budget for his logo, replies: "It was produced on a budget of blood, sweat, tears and frustration."

CLIFF JEW DESIGN

Design Firm:
Cliff Jew Design
Kensington, CA
Designer:
Cliff Jew

Design Firm:
Hoffman Design
Tucson, AZ
Art Director:
David E. Hoffman
Designer:
David E. Hoffman

HOTHOUSE
DESIGN + ADVERTISING

Design Firm:
Hothouse Design +
Advertising
Boulder, CO
Creative Director:
Jing Tsong
Designer:
Kurt Simmerman

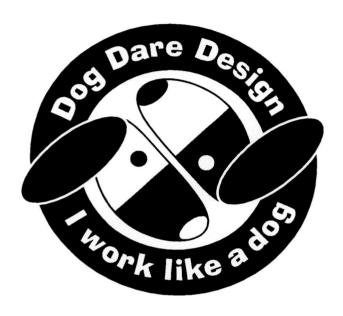

Design Firm:
Dog Dare Design
Highland Heights, KY
Designer:
Betsy Wernert

Discovery

Definition

Development

Delivery

Design Firm :
Thom & Dave Marketing
Design
Media, PA
Art Director:
Thom Holden
Designers:
Dave Bell,
Gins
Illustrator:
Gins

Design Firm:
Allison Saviano Design
Los Angeles, CA
Creative Director:
Allison Saviano
Designer:
Allison Saviano

Design Firm:
Design Phase
Terrace Park, OH
Owner:
Larry Hanes

Design Firm:
Office of Ted Fabella
Atlanta, GA
Designer:
Ted Fabella

DYAD COMMUNICATIONS

Design Firm:
Dyad Communications
Philadelphia, PA
Art Director:
Marylou Hecht
Designer:
Tom Maciag
Illustrator:
Tom Maciag

Design Firm:
IF Illustration & Design
North Lima, OH
Art Director:
Ilena Finocchi
Designer:
Ilena Finocchi

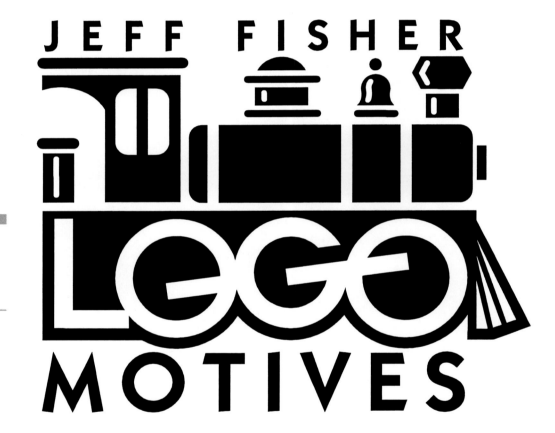

Design Firm:
Jeff Fisher LogoMotives
Portland, OR
Designer:
Jeff Fisher

Services

"What's in a name?" That seems to have been the first question the designers in this category asked themselves when faced with giving a service company an identity. Unlike retail businesses, where the goods for sale are tangible, companies that extend services to the private and corporate world offer fare that often cannot be described as easily in terms of atmosphere or physical appeal. These companies hover behind their names abstractly, requiring designers to find a way to load those names with as much meaning as possible, and to investigate the potential for communication each name contains. Could the name itself become a means of conveying what the company is about? If the name itself is utterly uninformative, could the designer use some element of the name, a single word or the initials, to achieve the desired effect? Or could illustration alone be used, hieroglyphically, to represent the name without characters?

A prime example of inventive typography that communicates all the essential information is David Martin's logo for Karg Electric, an electrical contracting company. He came up with his electric plug/negative space *E* solution after trying out others that did not, as he puts it, contain quite the same "element of surprise." To ensure that the client got the full effect of the design on the first viewing, Martin did not explain the camouflaged letter beforehand, allowing him to figure it out for himself. Says Martin, "It took him about half a minute, and then there it was! He saw the *E*, and his eyes lit up—perfect for an electrician." Cameron Smith of Swieter Design also found a way, albeit a more abstract one, to combine the client's initial with a sense of the client's business. The *M* of Dennis Murphy Photography, rendered in brown dots of varying sizes and tones, mingles with similar green dots that provide a subtly contrasting field. The design firm wished to avoid any obvious photography-related imagery, instead "focusing the viewer on the subtleties of visual perception."

Russ and Ruth Wall at Squeeze, Inc. had a more difficult time with their client's appellative, Chess Pacific. They felt this title had little or nothing in it that one could link to either the company's business, luxury construction, or its location in Arizona. At first, they too aimed for a solution that would consist of the company's initials. One discarded idea rendered the letters three-dimensionally, then crowned them with the crenellations of a chess castle. In the end, though, the designers turned to illustration. Still using the chess tower, they rendered it in the style of a Leonardo mechanical drawing, using PhotoShop to give the illustrated art an aged look.

Clint Gorthy at Principia Graphica had a more malleable problem with the name of his client, Golden Optical. The initials *GO* clearly lent themselves to the round shape of spectacles. Also, the letters could be used as the first two letters of "Golden" in a logotype. When, in addition, the client expressed a fondness for lorgnettes, Principia saw the way clearly to a solution: A gold, foil-stamped and embossed lorgnette, deco-style, with the initials incorporated as eye-frames.

While Principia chose to merge type and imagery into a single statement, other firms preferred to run the printed version of the company name alongside its visual embodiment. For Oak River financial Group, Michael Lee wanted to "establish an image of knowledge, strength and stability, and keep it simple." An iconic rendering of an oak standing in front of a river carried the correct connotations. Bob Shea's design for a company that represents stand-up comedians also visually interprets the client's name, Stand Up, but with a humorous play on words. Rather than trot out some hackneyed comedian imagery, Shea took a fresh look at the words "stand up." The result: an armchair with spikes protruding from the seat. He enhanced this clever visual pun by creating it out of old engravings and printing it via offset lithography, giving it an aura of Gorey-esque, Victorian discomfort. Nota bene: His clients ended up getting this charming design at no cost, largely because their only stipulation was that the logo be "cool and clever;" beyond that, they trusted his judgment. Shea's other client at the time, who was making his job difficult with excessive demands, paid extra, which allowed Shea to do the Stand Up logo for free, as he had wished. Moral: A little trust can go a long way when you want a designer to make your name.

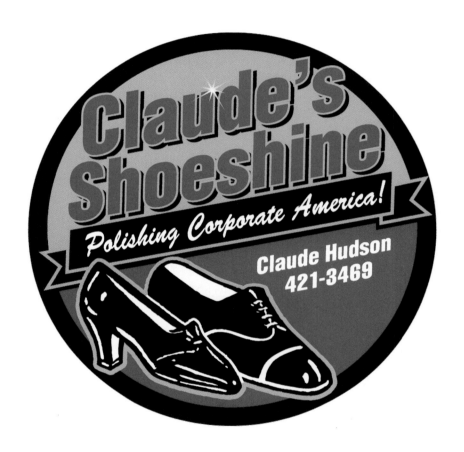

Logo for a shoeshine establishment.

Agency:
Broderick/Bates Advertising
Jackson, MS
Art Director:
Morris Spears
Creative Director:
Steve Tadlock

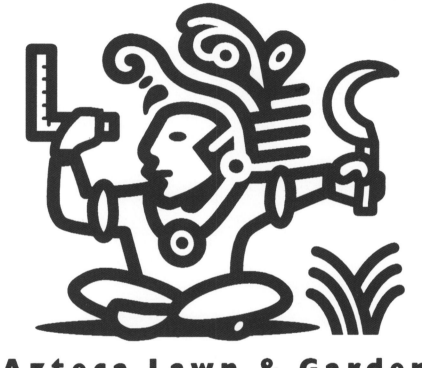

Azteca Lawn & Garden

Logo for a landscape and maintenance company.

Design Firm/Agency:
Michael Sanchez Creative
Service
San Francisco, CA
Designer:
Michael Sanchez
Illustrator:
Michael Sanchez
Client:
L. Cepeda

Logo for an architectural firm.

Design Firm:
The Office of Ted Fabella
Atlanta, GA
Art Director:
Ted Fabella
Designer:
Ted Fabella

Logo for a finance/investment management company.

Design Firm:
Michael Lee Advertising &
Design, Inc.
Beaumont, TX
Art Director:
Debbie Stasinopoulou
Designer:
Michael Lee
Illustrator:
Michael Lee

*An unpublished logo for
a support group for
mothers.*

Design Firm:
Asher Studio
Denver, CO
Design firm owner:
Connie Asher
Designers:
Connie Asher,
Trish Cummings
Illustrator:
Trish Cummings

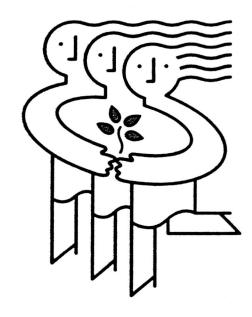

M O M S F O R M O M S

home**works**

Logo for a general contracting company that also offers handyman services.

Design Firm:
Cronin Design
Nashville, TN
Art Director:
Karen Cronin
Designer:
Karen Cronin
Client:
Jonathan Levy

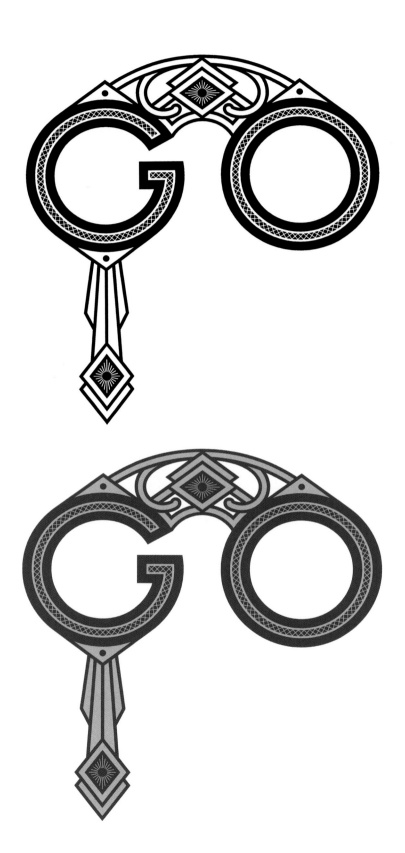

Logo for an optometrist.

Design Firm:
Principia Graphica
Portland, OR
Art Directors:
Robin Rickabaugh,
Heidi Rickabaugh
Designer:
Clint Gorthy
Illustrator:
Clint Gorthy
Client:
Dr. G.R. Nelson

Logo for a company offering personal training services.

Design Firm:
[i]e design
Studio City, CA
Art Director:
Marcie Carson
Designer:
David Gilmour

The
Fitness Choice

Logo for a company that represents stand-up comedians.

Design Firm:
Yellow Design
New York, NY
Designer:
Bob Shea

THE
STAND UP
COMPANY

Logo for a company that produces film, video, and marketing pieces for political candidates.

Design Firm:
Hovis Design
Austin, TX
Art Director:
Matt Hovis
Designers:
Matt Hovis,
Kevin Whitley

MAVERICK MEDIA

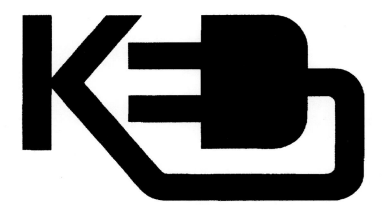

*Logo for an electrical
contracting company.*

Design Firm:
Martin Design
Plymouth, NH
Creative Director:
David Martin

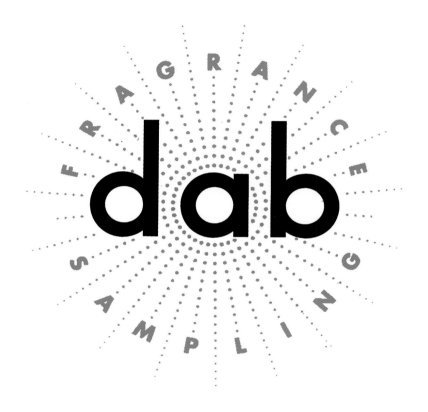

Logo for a company that distributes fragrance samples in dispensers to restaurants.

Design Firm:
Mires Design
San Diego, CA
Art Director:
John Ball
Designers:
Miguel Perez,
Jeff Samaripa

Logo for a commercial photographer.

Design Firm:
Swieter Design U.S.
Dallas, TX
Designer:
Cameron Smith

*Logo for an upscale
construction company.*

Design Firm:
Squeeze Inc.
Phoenix, AZ
Art Directors:
Russ Wall,
Ruth Wall
Designers:
Russ Wall,
Ruth Wall
Illustrator:
Russ Wall

Write Brain

W O R K S

Logo for a freelance
copywriting service.

Design Firm:
GSD&M
Austin, TX
Designer:
Brett Stiles

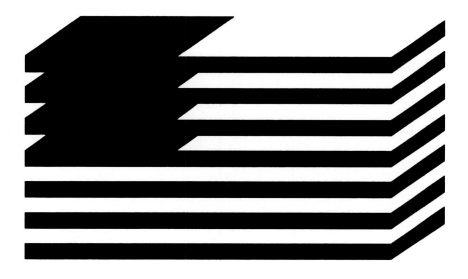

Logo for an independent wholesale lumber distributor.

Design Firm:
Slaughter Hanson
Birmingham, AL
Art Director:
David Webb
Creative Director:
Terry Slaughter
Illustrator:
David Webb

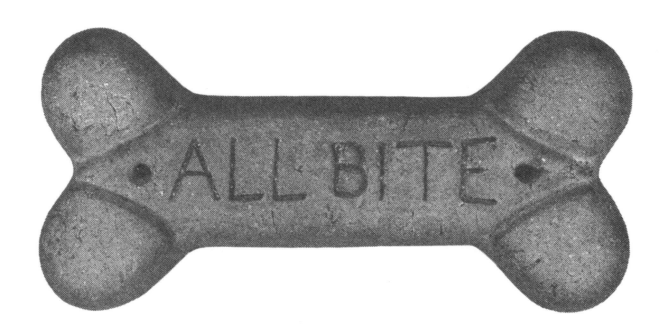

Logo for a print management and production company.

Design Firm:
Weirdesign
New York, NY
Art Director:
Steve Weir
Designer:
Sylvia Roman

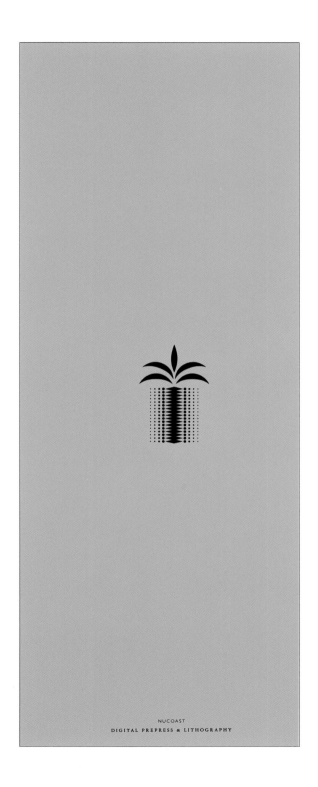

Logo for a digital and offset printing company.

Design Firm:
Michael Dula Design
Irvine, CA
Creative Director:
Michael Dula
Designer:
Michael Dula

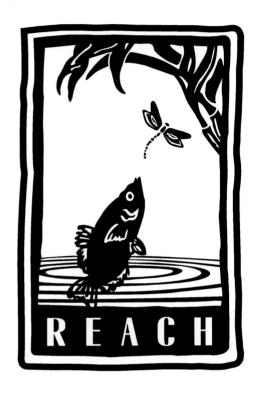

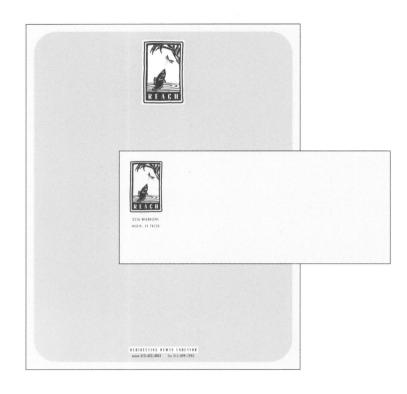

Logo for an international training and consulting firm.

Design Firm:
Molly DiCarlo Design
Atlanta, GA
Art Director:
Molly DiCarlo
Designer:
Molly DiCarlo
Illustrator:
Molly DiCarlo
Writer:
Logynn B. Ferral

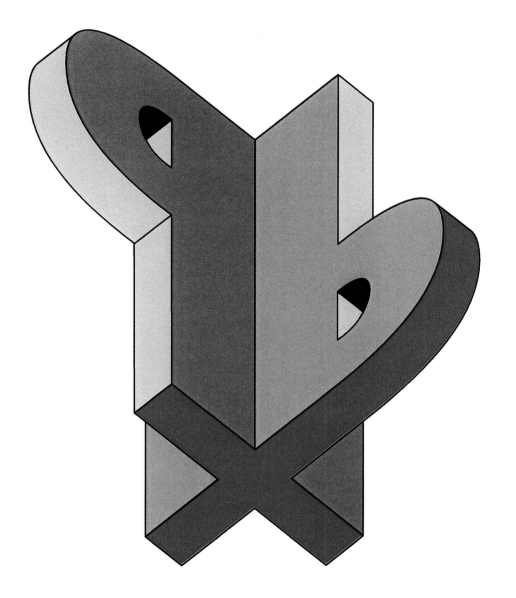

PbX Corporation
205 N. W. 63rd Street
Suite 305
Oklahoma City, OK
73116-8209
405-842-6688
Fax: 405-843-5095

Logo for a company that removes lead-based paint from bridges and water towers, replacing it with environmentally safe paint.

Design Firm:
Kükes Design
Springfield, MO
Art Director:
Troy Kükes
Designer:
Troy Kükes

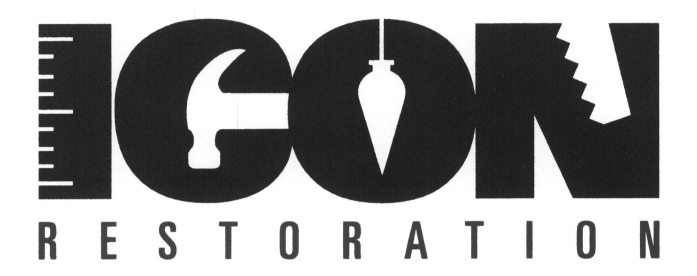

Logo for a company that handles insurance restoration claims.

Design Firm:
B-Man Design Inc.
Atlanta, GA
Art Director:
Barry Brager
Designer:
Eric Etheridge
Illustrator:
Eric Etheridge

FITZSIMMONS/MURRAY ARCHITECTURE

*Symbol for an
architectural firm.*

Design Firm:
FJCandN
Salt Lake City, UT
Art Director:
Matt Manfull

Index